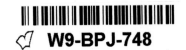
Art.Rage.Us.

Art and Writing by Women with Breast Cancer

Introduction by Jill Eikenberry
Epilogue by Terry Tempest Williams

SPONSORED BY

THE BREAST CANCER FUND

THE AMERICAN CANCER SOCIETY, SAN FRANCISCO BAY AREA

THE SUSAN G. KOMEN BREAST CANCER FOUNDATION, SAN FRANCISCO CHAPTER

CHRONICLE BOOKS

SAN FRANCISCO

Library of Congress Cataloging-in-Publication Data available.

ISBN 0-8118-2130-7 (pb), 0-8118-2146-3 (hc)

Designed by Brenda Rae Eno.
Printed in Hong Kong

Distributed in Canada by
Raincoast Books
8680 Cambie Street
Vancouver, B.C. V6P 6M9

10 9 8 7 6 5 4 3 2 1

Chronicle Books
85 Second Street
San Francisco, CA 94105

Web Site: www.chronbooks.com

Permissions

Grateful acknowledgment is made to the following for permission to reprint
previously published material:

ELLEN GOLDSMITH
"Chemotherapy" (p. 88) and "Ghost" (p. 165), from *No Pine Tree in This Forest
Is Perfect,* by Ellen Goldsmith (Slapering Hol Press, 1997). Copyright © 1997
Ellen Goldsmith. Reprinted with permission of the author.

LOIS TSCHETTER HJELMSTAD
"Double Amputee" (p. 55) "Force of Habit" (p. 78), "With Right of Survivor-
ship" (p. 132), and "Affirmation" (p. 134), reprinted from *Fine Black Lines:
Reflections on Facing Cancer, Fear and Loneliness.* Copyright © 1993 Lois Tschetter
Hjelmstad. Reprinted by permission of Mulberry Hill Press, Englewood,
Colorado. To order, please call 800-294-4714; fax 303-806-9313;
E-mail hjelmstd@csd.net

ELIZABETH HURST
"For the Time Being" (p. 80) first appeared in the Fall 1997 (Vol. 19, No. 4)
issue of *WomenWise: A Publication of the Concord Feminist Health Center.* Reprinted
by permission.

SUSAN E. KING
Excerpts (pp. 76-77) from *Treading the Maze* (Chronicle Books, 1997). Reprinted
by permission of the author.

JENNY LEWIS
"Doctor 20th March, 1985" (p. 22) is taken from the book, *When I Became an
Amazon,* a poetry sequence by Jenny Lewis, illustrated by Tinker Mather, and
published in the United Kingdom by IRON Press at £5.99p, ISBN 906228 60 3.

RELLA LOSSY
The poems "Prayer to My Daughter" (p. 159) and "Returning Calls"
(p. 87) are reprinted from *Time Pieces,* published by RDR Books, Oakland,
California. Copyright ©1996 Rella Lossy.

SUSAN HERPORT METHVIN
The poem "Breast Imaging" (p. 18) first appeared in *Moving Out: A Feminist
Literary and Arts Journal,* Vol. 13, 1987.

CHRISTINA MIDDLEBROOK
"Sailing" (pp. 148-154) is chapter 11 from *Seeing the Crab: A Memoir of Dying* by
Christina Middlebrook. Copyright © 1996 by Christina Middlebrook. Reprinted
by permission of Basic Books, a division of HarperCollins Publishers, Inc.

PEGGY ORENSTEIN
"Jan. 31" (p. 129) and "Feb. 15" (p. 131) first appeared as part of a longer
article, "Breast Cancer at 35," in the *New York Times Magazine* of June 19, 1997.
Copyright © 1997 by The New York Times Co. Reprinted by permission.

PAMELA ROBERTS
"A Brief History of My Breasts" (pp. 58-59) was first published in *Koroné.*
Reprinted by permission of the author.

TERRY TEMPEST WILLIAMS
"Clearcut" (pp. 168-69). Copyright © 1997 by Terry Tempest Williams.
Reprinted by permission of the author. Excerpt from " One Story, " by W. S.
Merwin, copyright © 1989 by W. S. Merwin. Permission granted by the author.

THIS BOOK

IS DEDICATED TO

THE ERADICATION OF BREAST CANCER

WITH GRATITUDE TO

GENENTECH BIOONCOLOGY

FOR GENEROUS SUPPORT

OF Art.Rage.Us.

PERSEPHONE'S RETURN

Joyce Radtke

1995

21″ x 28″

Oil Pastel, Water Color, Colored Pencil

After I was diagnosed with cancer, I became fascinated by the story of Persephone, the Greek goddess of eternal spring, of innocence. Abducted to the Underworld, Persephone ate the seeds of the pomegranate, symbol of fruition and creativity. Eventually, she was released, innocent no longer. I imagine that she felt she had a new chance to find her life again, to embrace the light. Like Persephone, I journeyed in the dark realms and used the seeds of creativity to find my way home. By imagining myself as the goddess of eternal spring, I was able to escape from the pain, the grieving, the dark and barren landscape the doctors painted for me. I have returned to the light, to living moments as they come and embracing every second I have.

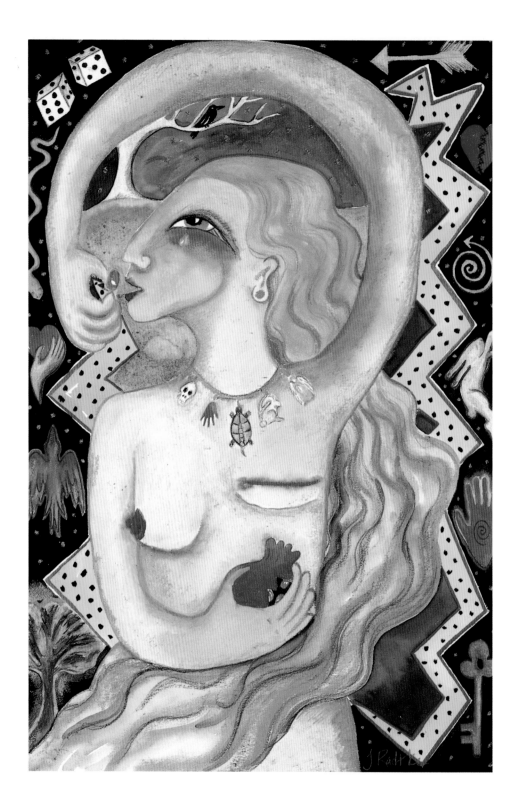

TABLE OF CONTENTS

ACKNOWLEDGMENTS 6

PREFACE 7

INTRODUCTION
by JILL EIKENBERRY 9

Change
15

Journey
63

Healing
121

EPILOGUE
by TERRY TEMPEST WILLIAMS *168*

ARTISTS/WRITERS *170*

APPRECIATIONS *173*

ACKNOWLEDGMENTS

Designer: Brenda Rae Eno

Editor: Jacqueline A. Tasch

Photographers: Kit Morris
 Gwen Rodgers

Cover Photograph: Sanders Nicolson

Title and Cover Concept: Sperling Sampson West

Cover Photography: Sanders Nicolson
Art Director: Greg Sampson
Model: Nina Omosoto
Body Painting: Sarah Bee
Model Making: Matthew Wuit
Photo Assistant: Richard Birch
Printer: Darren Hedges

Reviewers: Nancy Bruning
 Elspeth Martin

Art.Rage.Us. *Project Coordinator:* Susan Claymon

Sponsor Organization Coordinators:

The Breast Cancer Fund
 Andrea Martin
 Moli Steinert

The American Cancer Society, San Francisco Bay Area
 Gayle Hagen
 Nancy Kulchycki
 Kathy Severson

The Susan G. Komen Breast Cancer Foundation,
 San Francisco Chapter
 Sally Coates
 Devereaux Smith

PREFACE

Art.Rage.Us. began with a vision. One of the leading breast cancer activists in America, Andrea Martin, knew that an exhibit of creative works by women with breast cancer would be a powerful way to increase public awareness about breast cancer in the San Francisco Bay Area. As founder of The Breast Cancer Fund, Andrea began to research the possibilities. She teamed up with Susan Claymon, another longtime breast cancer advocate, and very soon, a landmark coalition was formed. The Breast Cancer Fund, American Cancer Society (San Francisco Bay Area), and the San Francisco chapter of the Susan G. Komen Breast Cancer Foundation, three leading national nonprofit organizations, decided to co-sponsor the presentation of *Art.Rage.Us.*

A Planning Team representing many groups, individuals and constituencies in the Bay Area began meeting in the spring of 1996. The Call for Entries went out all across the country in May 1997; hundreds of artists and writers responded. Two juries had the honor and pleasure of seeing incredible creative efforts from many women living with breast cancer, and some entries from families of women who have died of breast cancer. The work they chose was exhibited at the San Francisco Main Library Gallery from April 24 through June 14, 1998.

The *Art.Rage.Us.* exhibit served as a platform for many educational and fundraising events. Seven weeks of programming provided one of the most significant forums on breast cancer ever presented. In addition, this beautiful book was created with the collaboration of Chronicle Books, Inc., making the collection of paintings, drawings, sculpture, poetry, essays and many other art forms accessible to people across the United States and in many countries throughout the world. This commemorative catalog serves as a timeless legacy, allowing the voices and visions of *Art.Rage.Us.* to reach beyond the Bay Area exhibit, sending a message about the enormity of the issue of breast cancer everywhere.

This *Art.Rage.Us.* collection is unique, because it presents many visual and written works of art, along with intensely personal statements from each artist. These statements provide a window into the hearts and minds of these women who, inspired to create in the face of pain and adversity, present the art and outrage of breast cancer.

Intensely personal statements from each artist . . . provide a window into the hearts and minds of these women who, inspired to create in the face of pain and adversity, present the art and outrage of breast cancer.

> . . . these beautiful works of art and writing will provide spiritual fuel for those living with breast cancer to keep fighting, and for those who do not have the disease to be deeply moved by the creative power of art.

The Breast Cancer Fund is a nonprofit organization working nationally and internationally to confront the breast cancer epidemic by finding better ways to detect, treat, and ultimately prevent the disease. The Breast Cancer Fund is also dedicated to making sure the best possible medical and psychological care is available for women living with breast cancer. "Start-up" funding is provided to cutting-edge research projects that may provide breakthroughs in the battle against the disease, as well as to innovative education, patient support, and advocacy programs. The Breast Cancer Fund also conducts its own advocacy campaigns and works in collaboration with other organizations to build broad public support for all efforts to eradicate deaths from breast cancer.

The American Cancer Society is a nationwide, community-based nonprofit organization fighting cancer through research, education, advocacy and service. The Society's Breast Cancer Network, which provides a coordinated approach to the disease, was created to fund research to find a cure for breast cancer; ensure that every woman in America has access to screening for early detection and to timely, state-of-the-art treatment; provide accurate information on treatment options and community services; and save lives. The American Cancer Society is a strong advocate for effective public policy on breast cancer issues, both in Congress and in state legislatures throughout the United States. Local volunteers offer education to underserved women, as well as support and services to women in all phases of cancer treatment and recovery.

The Susan G. Komen Breast Cancer Foundation is a nonprofit corporation dedicated to eradicating breast cancer as a life-threatening disease. Volunteers work in chapters nationwide to advance breast cancer research, education, screening and treatment. The Foundation has become the largest private funder of research in the U.S. dedicated solely to breast cancer, with its Race for the Cure® growing to the largest series of 5K runs in the country. For the past nine years, the San Francisco chapter has funded a detection program for women with limited resources as well as numerous community breast cancer grants.

Funds raised through the *Art.Rage.Us.* project are being used to provide vital service programs throughout the San Francisco Bay Area, with particular focus on reaching underserved women. In addition, funds will go to research into the causes of breast cancer.

The *Art.Rage.Us.* project has been a unique and wonderful collaborative effort. With the co-sponsorship of three outstanding organizations, these beautiful works of art and writing will provide spiritual fuel for those living with breast cancer to keep fighting, and for those who do not have the disease to be deeply moved by the creative power of art.

RESONANCE

Truth, and in particular, emotional truth, has an extraordinary power to sway us, I've always thought. Anything that's truly personal will move us all, even if it's about experiences we've never shared and people we don't know. I believe this is the magic that animates the works gathered in *Art.Rage.Us.,* works that are a response to the diagnosis of breast cancer and the life change it engenders. These intense expressions of pain and fear, of hope and healing, reveal the artists' new discoveries about the gift of life. They touch us at our very core.

Women who live with breast cancer often find themselves getting down to what's essential. These 56 artists and 21 writers have gone deep into themselves and come up with unique and distinctively personal perspectives on what has happened to them. Wry, wistful, angry, sad, whimsical, and defiant, all of these works bring us honest emotions, honestly expressed. They are so remarkably effective because they are telling us the truth, and the truth resonates for everyone.

As women, we go through our lives with a lot of different facades that we feel we need in order to deal with the world. Like the characters I have played, these facades are roles we assume, some of them very much like us, others that have little in common with our heart and soul. There's something about living with a disease like breast cancer that starts to peel away those layers and move us into a deeper core place. That's a pretty amazing place to create from.

When I was diagnosed with breast cancer in 1986, my husband Michael and I had just begun working on the TV series, *LA Law*. In a sense, my creative work—playing the character of Ann Kelsey—helped me to get through the difficult times after diagnosis and during treatment, a lumpectomy followed by radiation therapy. I was playing a winner, an aggressive woman with big hair and big suits who walked into a boardroom and intimidated all of the guys. At home, at night, I was struggling with a lot of fear. But during the day, on the set, I had to put aside my victimness to "become" Ann.

Over the course of the years after diagnosis, while *LA Law* was making Mike and me "rich and famous," my acting became much more personal. My experience with breast cancer enriched our lives as actors and as people. As we went deeper and deeper into ourselves, we began to change. By the time *LA Law* ended, it felt good to let Ann Kelsey go because I was getting really excited about being myself in front of audiences. Although we still act, Mike and I now spend much of our time speaking directly to groups about what is most important to us: how to love each other.

I recognize this stripping away of facades in many of the writings and art works on these pages. To me, it explains why many of the portraits include bare chests and bald heads. These women have gotten to the point where telling the truth is far more important than worrying about what people might think. And in fact, the power of their honesty makes them quite beautiful. Some of these works are paintings or drawings, like Sylvia Colette Gehres's haunting depiction of the strange, bald, one-breasted woman who stared back at her in the mirror, her favorite earrings the only familiar element. Others are photographs, like Margaret Stanton Murray's "Figure #1," one in a series

> I don't want to imagine
> the bone-cold fear that
> must strike a woman whose
> daughter has been diag-
> nosed with breast cancer.

that chronicles the surgical process at the same time it shines with her courage.

A favorite of mine is Diana C. Young's photograph of herself (after a double mastectomy) with six close friends and one woman's daughter, all of them naked to the waist. There's a factual statement being made by the photograph: The risk of breast cancer over a woman's lifetime is one in eight. But that message is overwhelmed by the warmth the group generates, their charm and naturalness. You can almost see the support the artist drinks in from her friends as she faces the challenge of cancer—and who can handle this kind of crisis alone? Diana says that when the shoot was done, the women were reluctant to put on shirts and sweaters again. I can understand why, for physical nakedness can have an emotional counterpart in self-revelation. To truly be ourselves with others is a wondrous thing.

I am also drawn to the photograph of Gwen Rodgers. Her self-portrait shows a lovely young woman, beautifully bald as a result of her treatment for breast cancer. But as the mother of a 28-year-old daughter, I can't help but be struck by Gwen's youth. She could be my daughter. And my daughter could be in her situation.

I don't want to imagine the bone-cold fear that must strike a woman whose daughter has been diagnosed with breast cancer. Several of the artists and writers tell us about their own fears, and sadly, their experiences. Gloria Brown found it "particularly cruel" when her daughter Jennifer was diagnosed with breast cancer, only five years after Gloria's treatment for the same disease. Two paintings of mother and daughter show "what it felt like: dark and lonely and terrifying, but together." And Arlene G. Linder provides eloquent line drawings of her daughter's struggles through chemotherapy: "I want to hold her in my arms," Linder remembers thinking, "but she can't stand to be touched. Everything hurts her." Even the fear of such an outcome is chilling. Poet Susan B. Markisz recalls watching her little girl, "yearning for breasts," as she plays with Susan's prosthesis. When her daughter asks if she can have it, Susan's reply is also a wish, or perhaps a prayer: "No, never."

The mother and daughter relationship is also at the heart of Rella Lossy's eloquent poem, "Prayer to My Daughter," which uses a fragment of a child's prayer: ". . . and if I die before I wake. . . ." I was especially taken by this poem because I'm a nature person, and it talks about hikes that mother and daughter have taken to the Lost Coast and to Yosemite's high country. "Take my spirit to those places,/" Rella asks her daughter, "whisper me back into that earth/ that river, those rocks." Rella died of breast cancer on April 24, 1996, just a week after she had mailed galleys of her book, *Time Pieces,* back to the printer.

It's true that all of us will die some day; yet this is a truth we work hard to avoid. An experience with breast cancer makes denial harder. And when we look squarely at death, it makes us want to live in a different way. For me, and for many of the writers and artists in this book, the diagnosis was the proverbial "wake-up call" that urged us to do what we want and do it now. I began to seek out alternatives to acting. Ria Orans went to art school. Nancy Bellen got a tattoo—and then photographed it for this exhibit. Women who had never

used their creative abilities called upon them now, and professional writers and artists found their creativity revitalized.

This is not to say that it's "good" to have breast cancer, but only that people can find meaning even in the bad things that happen to them. This is true even for those who are facing an untimely death because of their diagnosis. Christina Middlebrook's essay, "Sailing," is a particularly potent expression of the anxieties and dreads that accompany such a verdict. Her voyage on Lake Tahoe with her husband becomes an extended metaphor for their voyage toward her demise, growing accustomed to the fear.

There is no question that this book deals with some tough subjects, and some of the pictures are hard to look at, at least at first, because they are full of pain as well as truth. Marlene Gharbo Linderman evokes the nightmare experience of mastectomy in an operating room scene that is so savage I can feel it in the pit of my stomach. And Mary Ellen Edwards-McTamaney portrays a woman's face "as the deadly seriousness of her diagnosis hits her." Women who are living with breast cancer will recognize the combination of horror and astonishment, surprise and fear, in her expression. I have an informal photograph taken of me around the time of my diagnosis. I wasn't telling anybody about my situation then, but you can read my feelings on my face: We all look like that.

But there is humor as well, although it may be humor with an edge. Members of a San Francisco survivors' group called Transforms converted the body mold that positions women for radiation therapy into a floating tray bearing cocktails in an advertisement for the imaginary Carcinoma Inn and Spa. Carol Sue Holbrook wrote a classified ad seeking "new tenants" for a vacancy on her chest. In a revision that retains the loveliness of the original, Carole Bonicelli redrew Botticelli's *Venus,* minus one breast. I see another more subtle change. The eyes of Carole's *Venus* are sadder and wiser. One of my favorite pieces is Gwen Thoele's "Our Lady of Perpetual Health," who wears broccoli to ward off recurrence and carries a banana in a surgical-gloved hand.

And there is a great deal of love. Under the pressure of meeting breast cancer's challenges, bonds of incredible strength and durability can be formed. Not surprisingly, there are a number of collaborative efforts in this book: Nava Frank and Anita Bowen, Susan Dooley and Kathy Geiger, Sharin Smelser and Imogene Hubbard, Pam Golden and Johnna Albi. Anita and Susan helped Nava and Kathy chronicle their treatment and recovery. Imogene combined photos Sharin took with her own pictures of industrial plants to make a statement about the possible environmental causes of cancer. The sculpture "Johnna Becomes a Birch Tree" began as a face mask that was a symbol of hope. It became Pam's memorial to her fallen friend and a means of dealing with her intense grief.

In a very important way, breast cancer strikes not just individuals but all those who love them, family and friends. Husbands and other life partners are particularly affected. Lois Tschetter Hjelmstad remembers a night when her husband "reached/to caress my missing breast—/I felt him cringe/and he slowly/withdrew his hand/hoping I had not noticed." In another bed, Merijane Block lay awake beside her partner, taking his advice and listening to the song of the foghorns, briefly finding "the way out of worry." And in a third, Patricia Watt's husband asks what he can do to make her feel better. "Sing to me," she said, and sing he did: "Good King Wenceslas looked out"—in the middle of July. There

is a marvelous portrait of Denny and Françoise Hultzapple, discovering that their loss of her breast has done no damage to the intimate relationship they had shared for more than 20 years. In the photograph, they hoped to capture "the healing energy being radiated and celebrated" by their reunion.

Many testimonies to the healing powers of love and of creativity are found on these pages. Some women summed up their experience in art so they could put it away. Barbara L. Peterson's "Memoria" is a handmade box containing broken bases of glass goblets, a sort of mini-casket for lost breasts. Sabina Schulze wove braids of the hair she lost during chemotherapy into strips made of latex gloves, surgical gowns, and pathology reports. She says the collage allowed her to "digest" the experience. And Heather Ann Gilchrist made a shadow box that incorporates photos and writings and objects that recall her experience. She says she worked at it on and off during her year of treatment as "an outlet for my anxiety."

Barbara J. Landi found healing as she "grew" a watercolor garden of vegetables like the ones she'd grown on her Alaska farm before diagnosis forced her to the city for treatment. "When I am laying down on paper the vibrant colors of my favorite crops, I taste the sweetness of the fruits in my imagination," Barbara says. "I stop thinking about cancer, and I go on with my life."

Kay Minto began thinking about the Nike of Samothrace during her hospital stay and set to work on her own version when she got home. Continuing with the welding even when she had doubts about the outcome, Kay had her reward when a wing attached to the body brought the piece alive. "My challenge now is to live day by day with the same trust I have when my art is unfolding," she says. "Completing the Nike was like graduating to a new stage of life, being transformed from an earth-bound being to a woman who can fly."

And so we find life truths here, as well as personal truths.

The works I have described were chosen because they struck me as typical in some way of the others, pointing out important themes that link all of these creative efforts. But I encourage readers to take time to visit all the stops on this trail. It begins with works describing the impact of the Change brought about by a breast cancer diagnosis. Then, there is the Journey through treatment, through radiation and chemotherapy, and adjustment to new physical and psychological realities. Although as yet there is no cure for breast cancer, there is Healing for all of these women.

Women who are living with breast cancer will find a community of experience and emotion here. They will nod their heads, perhaps weep, and I hope they will smile, too. Others will find a new understanding of the challenge so many women are bravely facing. Everyone who spends time with these artists and authors will marvel at the power of their creativity, the power of their truth. And the truth will lift our hearts and set us free.

Women who are living with breast cancer will find a community of experience and emotion here.

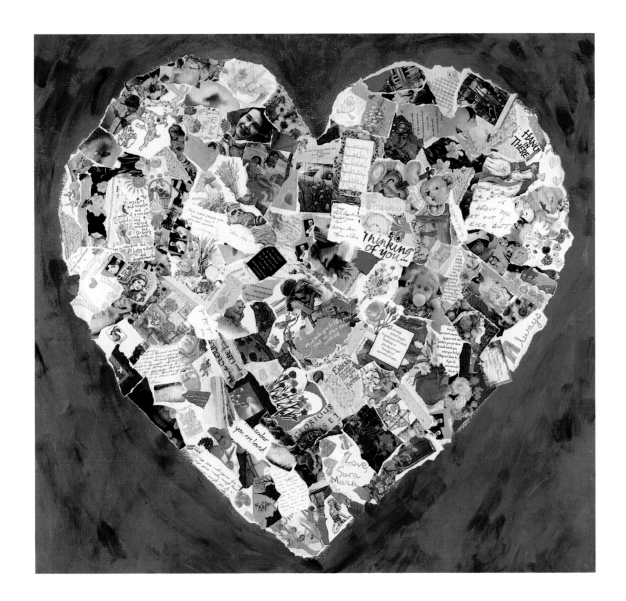

SUPPORT
Nancy Bellen
1996–1997
48" x 48"
COLLAGE

After I was diagnosed in September 1996, I received many cards from family and friends, and also from people I didn't know who had heard about me. The outpouring of support was incredible. I kept the cards on my mantle until it felt morbid to have them there. Then I remembered hearing a story about a family who lost their home in a fire. All that remained was a box of melted glass and silverware. They turned the contents of the box into a mosaic table for their new home. So I took the cards and turned them into an enormous collage of support. I worked on it through chemotherapy, surgery, and radiation, completing it toward the end of treatment in March 1997. I hope as my 4-year-old son gets older, this is what he remembers of this terrifying time: Mom's art work.

DIAGNOSIS 1
Mary Ellen Edwards-McTamaney
1994
18″ x 22″
MIXED MEDIA

Change

Horror and astonishment are written all over this woman's face as the deadly seriousness of her diagnosis hits her. She holds out her hand, covered in her own blood, not believing this could ever happen to her. This painting expresses my utter disbelief as I sat on the end of the examining table and heard my surgeon say, "I'm sorry to tell you this, but it is malignant." I felt unreal and full of dread. This couldn't be happening to me—but it was. And might again. I am still afraid.

—Mary Ellen Edwards-McTamaney

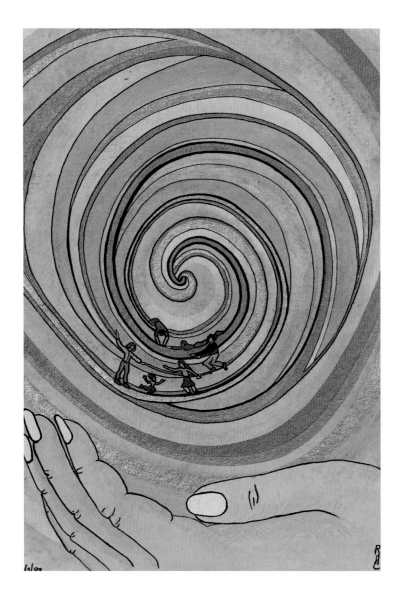

BIOPSY PREPARATION
Rosalie Ann Cassell
1989
10″ x 7″
WATERCOLOR AND INK

When the results of a routine mammogram showed a suspicious area, I was told I would need a biopsy. Panic! I've always liked my breasts, and visualization helped me as I waited for the dreaded procedure. My imagined internal helpers zoomed around inside my breast making it all healthy. In my mind's eye, they were luminescent, white, and spiritlike. But when I began to illustrate this (in the image above), my little helpers insisted on bright colored outfits and playful postures. They made me laugh and helped me keep the panic at bay. In the image at right, I visualized the tender love I felt for this part of my body. This calmed me and helped me face the challenge ahead.

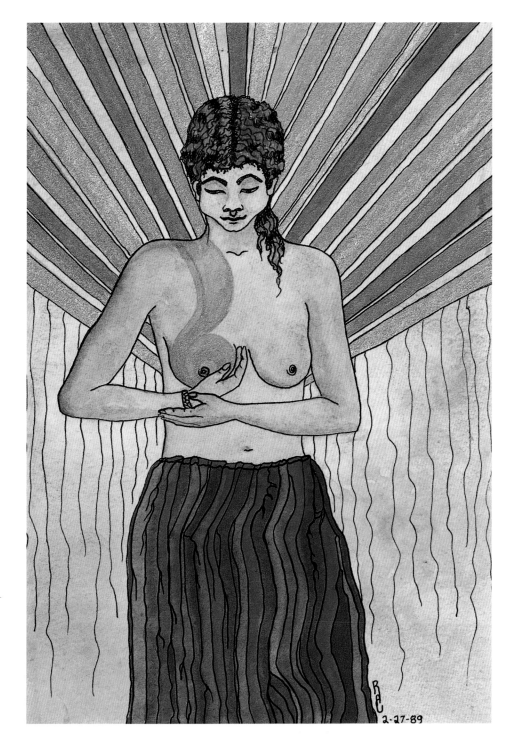

WAITING FOR THE BIOPSY

Rosalie Ann Cassell

1989

10″ x 7″

WATERCOLOR AND INK

Breast Imaging

Susan Herport Methvin

I was twelve, running with a friend,
when she asked if I could sense their weight.
We jumped over cracks in the sidewalk
and I smiled, for the first time feeling
my small breasts pull downward.

Now at the Regional Hospital's Imaging Center
infrared light scans my right breast.
On the screen, the nipple, outlined in grey.
The veins are blue and many fingered.
And there, a smudge, a flaw in the symmetry.

I think of all this right breast has seen:
at eighteen, my first love's hand caresses it,
tests how far he can go; the groom, free
to touch without guilt; the first child
eagerly drinks, her blonde hair and wet cheek
warming against me; the man I love
more than any other leans toward it,
his long fingers stroking its curve.

The technician places my breast
in a plastic vise for the mammogram.
I escape by recalling moonlight:
on top of my lover, I lean back, my body shining.
He reaches up toward my breasts, his hands
forming memory across them, then down
over my flat stomach, down to where we join.
And I was beautiful.

Sitting in the oncology center, I wonder
what will be left after tomorrow.
Will they carve out this imperfection,
or will they cut more and more,
sculpting my body?
Then what will be left
for the moonlight? What will be left
of the weight of my womanhood?
What will be left
for his hands?

Susan Herport Methvin

*I wrote "Breast Imaging" the night before my mastectomy.
I wanted somehow to honor my breast, to make it live
on. I knew bronzing it wouldn't work! So I decided to
write a poem about its history. I wanted to remember
the part it had played in my life. Writing the poem
was wonderful therapy.*

TITLE IX

Jeanne Hyland

1997

25³/₄″ x 10″ x 9″

BRONZE

I started this piece not long after I got a call saying I had an abnormal mammogram and about a week before my first biopsy. Working on the sculpture gave me something to focus on in the here and now, avoiding the flights of mind into the realm of fear/fantasy and worst-case scenarios. Feeling the physicalness of the clay and working with my hands were calming and reassuring. Working on this figure and perfecting its form made my mind slow down and appreciate what I have to live for and contribute. The figure started out being a celebration of women's achievements in athletics, but as time went on, it also became a tribute to the bravery of women who have fought breast cancer.

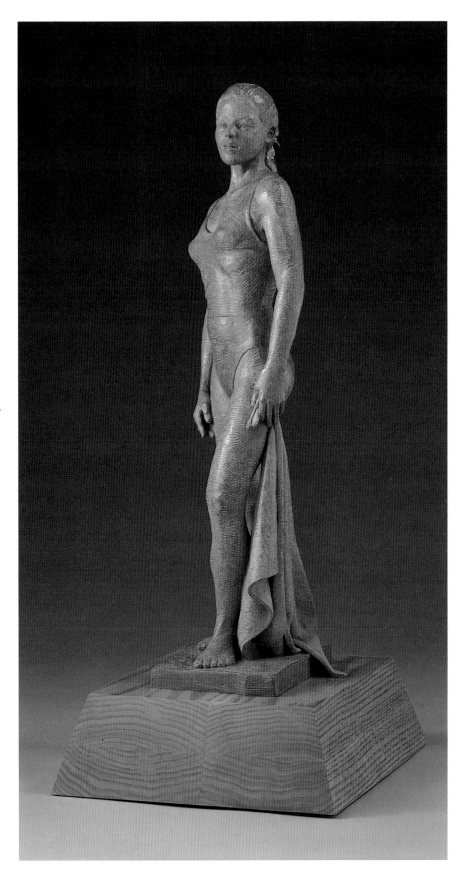

DANCE
Gwen Thoele
1996
22" x 26"
Oil

This painting expresses all my tangled feelings about surgery. It's an incredibly bizarre crap shoot in which we have no alternative but to trust the surgeon. When terrifying attacks on the artist's health are under way, art is sublimation.

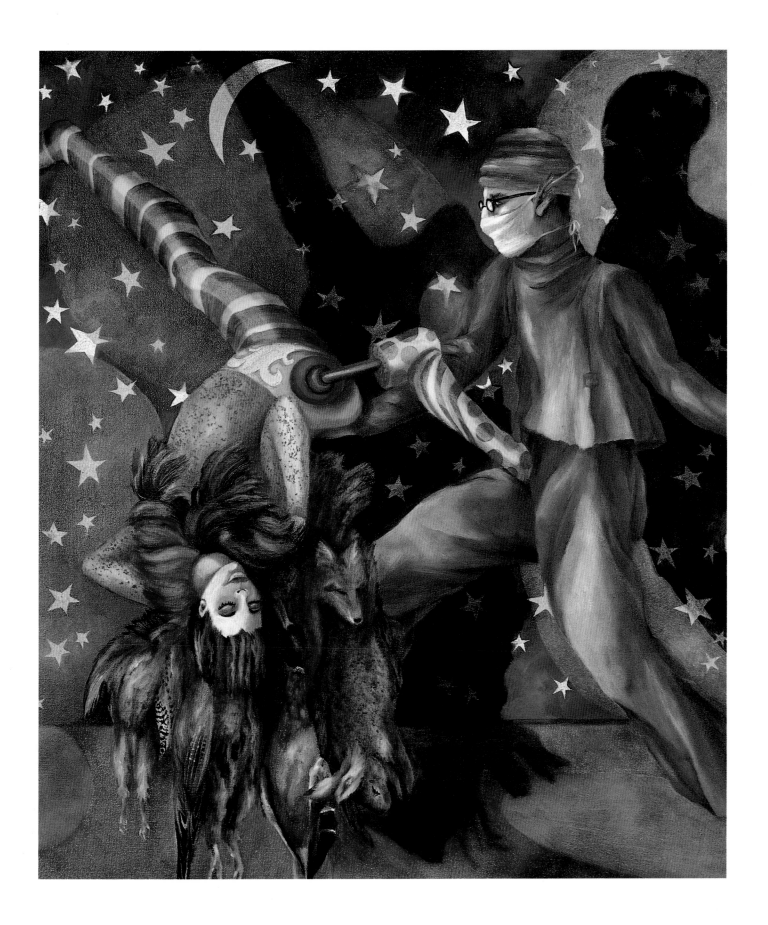

Doctor

20th March, 1985

Jenny Lewis

As he talks his hands jump in and out
of his pockets, square hands,
brave with the exact science
of mending faulty instruments.
(And the pain of his knife
is like violin strings breaking.)

His white coat gives him immunity
against our germs, and griefs—
our women's longings for love, babies
and healthy breast tissue.

All we want is the right answer.
Pecking after facts, ignorant as hens,
eyes small with hope, only half digesting
what he says. All that technical data,
so patiently explained, falls before us
in a somber harvest to be winnowed blindly
for the magic words "non fatal."

But instead he tells me I am the one in twelve.
He cannot say how long I have to live
until the results of further tests come.

To the eleven others life is more benign.
They touch his hand, weeping with gratitude.
Then he turns his head away to avoid my eyes
which plead "save me."

And people come with unwanted gifts
of comfort and pity.

Jenny Lewis

In March 1985, I had a lumpectomy, then a radical mastectomy. I was told I might have only months (or weeks) to live. A friend sent me a card saying, "Dear Jenny, now you are a true Amazon!" Thinking of the legendary one-breasted warrior women made me smile and put me in touch with a part of myself that was determined to fight. I felt a surge of power connecting me to the "ancestor force" of women who have been gathering knowledge from the depths of the universe for thousands of years. Their capacity for endurance, their wisdom and courage, is all there, waiting for us modern women to tap into it. I hope people who read my work will find themselves reconnected to the vibrant energies of generations of mothers and be able to draw comfort and support from them, just as I was.

FACING PAGE:

BUSY DOCTORS SUPPORT CLUB
Eva Cockcroft (with Bruce Snyder)
1997
8½" x 11"
MIXED MEDIA

When confronted with the fact of breast cancer and having to deal with modern medicine, I found that a little humor (however sick or cynical) helped me to face the unthinkable. As I was walking around the hospital getting my pre-operative tests, I looked down at the form and saw it had the wrong breast written on it . . .

BUSY DOCTORS SUPPORT CLUB

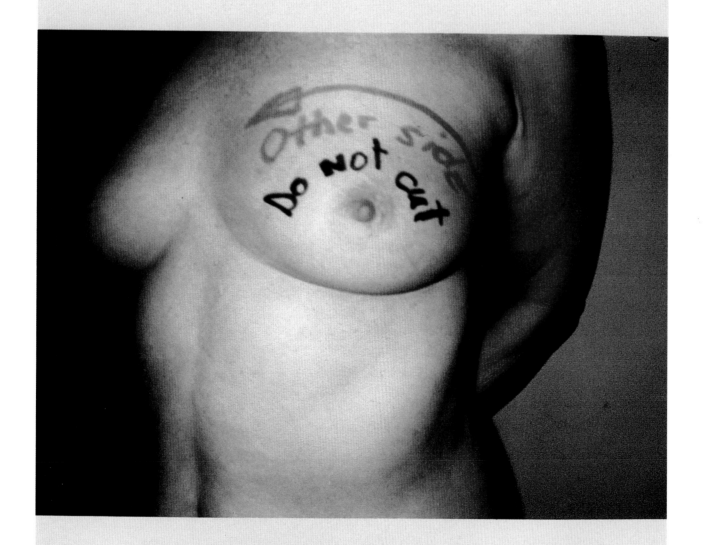

I've never been very big on faith.

Entering the Labyrinth

Linda S. Griggs

"We {do not} risk the adventure alone, for the heroes of all time have gone before us. The labyrinth is thoroughly known. We have only to follow the thread of the hero path, and where we had thought to find an abomination, we shall find a god. And where we had thought to slay another, we shall slay ourselves. Where we had thought to travel outward, we will come to the center of our own existence. And where we had thought to be alone, we will be with all the world."

JOSEPH CAMPBELL, *The Power of Myth*

November 15, 1993

I enter the hospital through a revolving door, just as a woman is being wheeled out, new baby in her arms.

All the halls look alike. Unable to remember the front desk's litany of straights and rights and lefts to get to surgery, I lose my way after the first turn. I keep asking directions, keep doubling back. Someone finally leads me to where I'm supposed to be. Once there, once I've exchanged my street clothes for my magic gown and slippers and paper cap, I lie down on the gurney and watch the ceiling lights as they wheel me deeper and deeper into the maze. The last light I remember is very bright, all colors.

When I wake up my husband is standing there with his arms full of presents: a "galaxy" robe with the moon and stars and the sun smiling out of a blue-black sky, a little tiger puzzle, a softball-sized pyramid with spirals painted on it. They keep delivering flowers and balloons with my name on them. It feels like a birthday.

I can barely raise my arm when I need to turn over. There is a tube coming out of my underarm, where my lymph nodes used to be, to drain fluids into a bottle pinned to my night shirt. I watch it fill up with a peach-colored liquid. It looks like fruit punch.

My husband is telling me about the book my mother sent that he read through my surgery, about the connection between psychological wellness and physical healing. I can feel him thinking this is somehow a plea for attention on my part. He points to all the flowers. "You know all these people love you, don't you?"

On the other side of the curtain I hear a man and woman talking low, laughing, joking. They are playing cards. She has tubes draining out her fluids

too. I know because the nurses are concerned that she is still draining. She's been there a week. When she tries to sit up straight on the bed, she's still in a lot of pain.

After the men leave, she calls to me through the curtain. "Your husband seems very supportive."

"So does yours."

"He's not my husband. My husband was really a jerk. He was playing around on me. I left him a year ago, after I had my lumpectomy."

"So you've been through all this before? How long did it take you to get your range of motion back?"

"I was playing golf a month later. You'll be back to normal in no time."

"And what are you in for this time?"

"A double mastectomy."

"You had a recurrence?"

"I took a chance. It didn't pan out."

They wheel me out to the front desk, my arms full of flowers and balloons. I leave the hospital through the revolving door, realizing this is the easy part.

Linda S. Griggs

I have come to believe that my breast cancer is not something that just came out of the blue. I believe my cancer was my body's way of signaling that something was not right about my soul/psyche. For true healing, I must tend to that underlying "dis-ease." As part of my healing process, I am currently working on a book-length piece of creative nonfiction about my breast cancer as a midlife "hero quest"—complete with a call to adventure, descent to the underworld, battles with dragons and ogres, and eventual return to the world with the "boon" of knowledge/healing. I believe I've been going through several hero's cycles—at least one a year since my diagnosis in 1993, just a month after my 43rd birthday—each one taking me to a different underworld, each one teaching me something different. The writing here is from the first cycle.

MY SURGERY
Marlene Gharbo Linderman
1996
48″ x 48″
Oil on Canvas

This painting describes a nightmare experience, a breast cancer mastectomy. I have tried to convey my feelings of fear and powerlessness, the absolute vulnerability of my body to the growing cancer predator, and the barbaric resolution of our engagement. I could not have created these paintings without having lived this experience. To me, art is about the internal search, the seeking of that which dwells within, beneath the surface. I hope you will not turn away without some feeling in the soul.

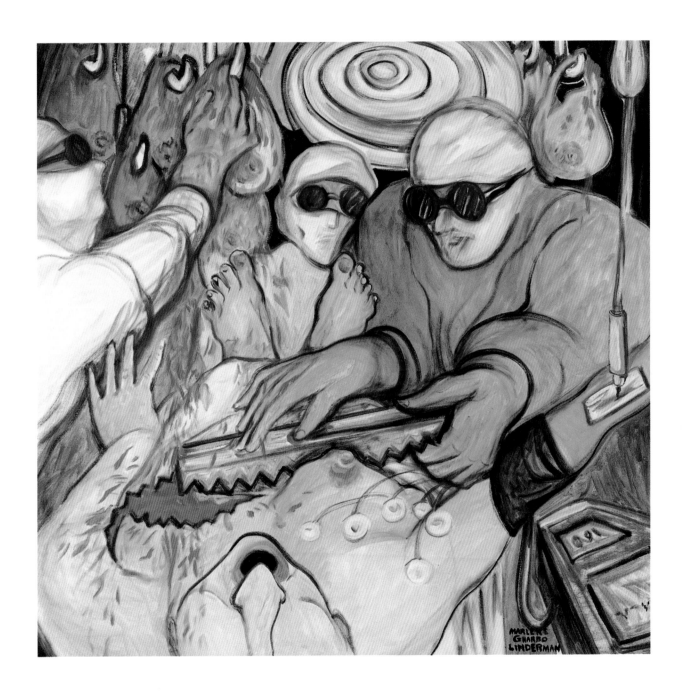

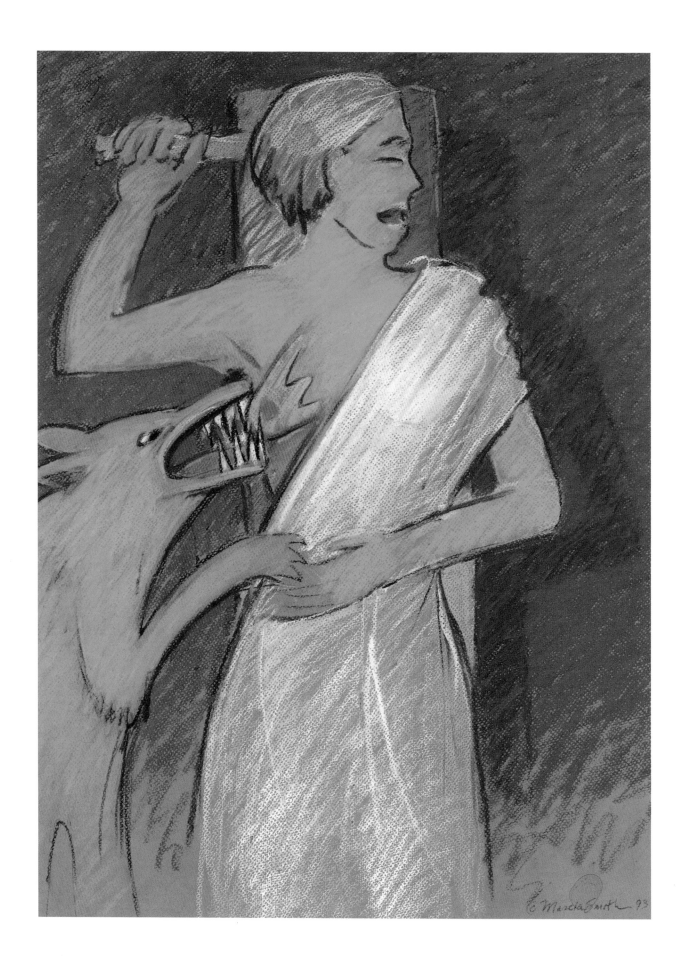

SURGERY MEMORY
Marcia Smith
1993
25¹/₄″ x 31¹/₂″
PASTEL

This image, "Surgery Memory," was done shortly after a session of guided visualization. In the session, a wolf spontaneously appeared and began tearing at my breast. I felt that what I was experiencing was the release of my body's subconscious memory of the surgery. I consciously felt the pulling and tearing of muscle tissues. Accompanying this pain was the realization that the surgery was a profoundly compassionate act, for it was helping me to stay alive.

"A Work in Progress"

(breast reconstruction)

Constance Richardson

I'm a work-in-progress,
not diminished or finished.
Re-engineered.

"Thank you" I say
to my abdominal muscle
for accommodating its move
north, its capillaries
a river of new life.

"Hooray" I say
for having too much belly
that became the donor site
and now my left breast.

"Pull!" I order
my flaccid obliques.
"Reach" I croon to one arm
as it struggles up, up, up.

"Patience" I say
to tight tendons, facie,
sore arms and torso,
as we metamorphose
in recovery together.

Constance Richardson

I am recovering from reconstructive surgery, called a Tram-Flap, and thankful for medical expertise and my insurance policy. I struggle with my newly engineered torso, which is often sore, won't do what it used to do, and needs my help and acceptance. I wrote this poem to thank my body for being so adaptable.

SELKIE THE SEAL/WOMAN
Wende Heath
1996
7" x 12"
CERAMIC AND LEATHER

During my recuperation from a lumpectomy, I saw the wonderful movie THE SECRET OF ROAN INNISH, *about a seal who becomes a woman. The first day I felt well enough to leave my houseboat, I walked to the beach and there, as if waiting for me, was a young seal swimming and watching me. I had never seen a seal in our harbor before and considered it a good sign. I saw her many times thereafter and we spoke of healing and life and death. Because of the amount of alone time I have spent sinking into the unconscious, I don't know if the figure is leaving the sealskin or pulling it back on. She is caught in the middle, holding her wounded breast.*

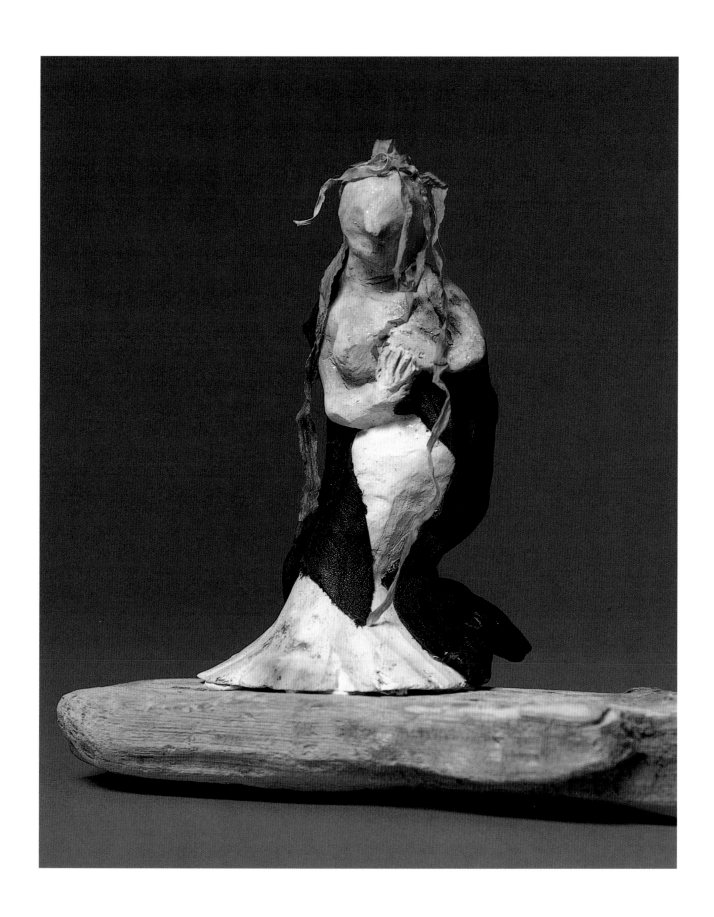

CAUSE
Sheila Sridharan
1996
22″ x 34″
Mixed Media

In September 1995, I was diagnosed with breast cancer. I had just celebrated my 47th birthday. After the surgeon called me with the news, my husband and I immediately left work, met each other, and cried. Then we went to the library and got stacks of books. By the time we met with the surgeon the following morning, I had already decided that I felt more comfortable with a mastectomy. I wanted the cancer completely out of my body. I was able to go into surgery on the faith I got from those who had gone before, women who had been through it and told me I would be fine. I believe my breast cancer was caused by hormones dispensed to me by doctors, beginning when I was 12 years old. In this picture, you can see some of the thousands of hormone pills I swallowed over the years.

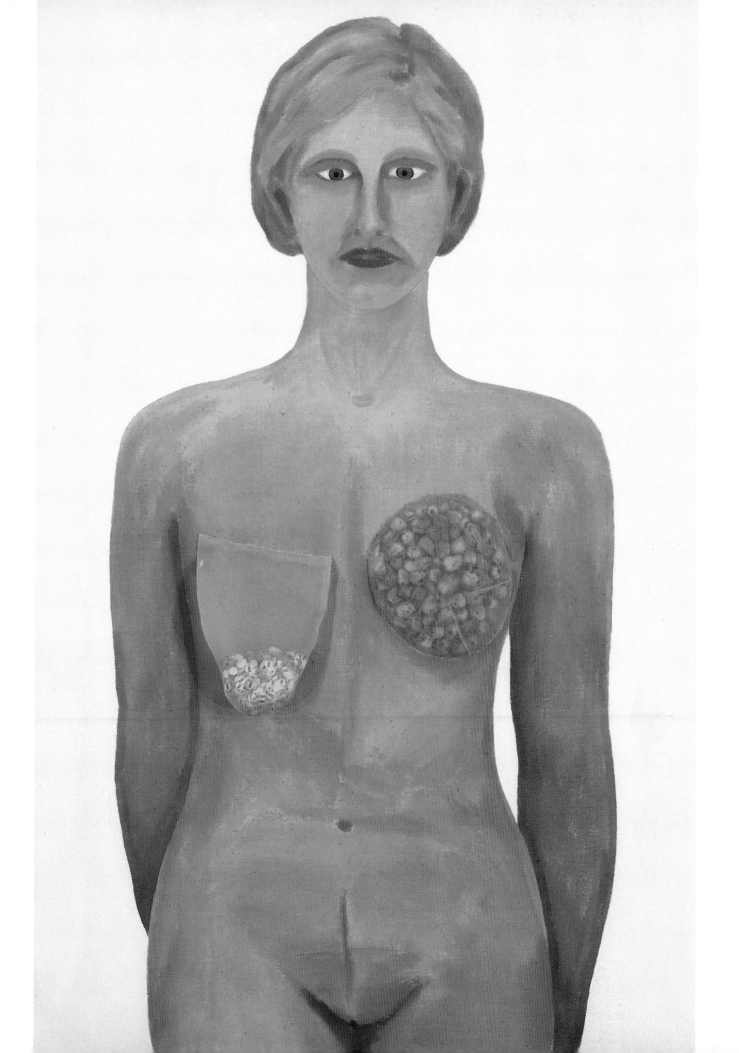

FIGURE #1

Margaret Stanton Murray

1991–93

60″ x 40″

BLACK & WHITE PHOTO MURAL

It took four biopsies to determine that I had invasive interductal carcinoma. During this time, I felt a great deal of anxiety. I wanted to have something from this moment, something I could hold on to, so that later I might be able to make sense of it. I began by recording the effects on my body of each biopsy session with simple color polaroid snapshots. Later, I used large format (4″ by 5″) black and white polaroid negatives to document the stages from the mastectomy through reconstruction. This began in earnest during the frenetic activity the night before the modified radical mastectomy on April 25, 1991. Intuitively, I felt drawn to ritualizing the passage. I made a photographic record of my body as it existed before the operation, using polaroid negative material so that I could be immediately assured that I had the image in hand. This photograph was taken five days after the operation, and my second day home from the hospital. It is one of six portraits from an installation that I call "Transfiguration."

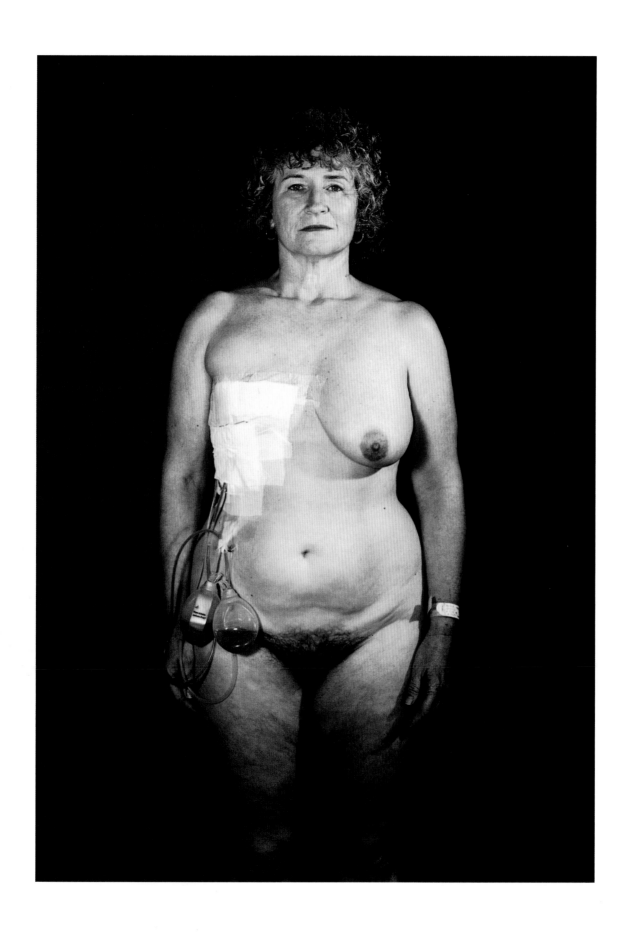

DEADLY MYTHS
Kelly ForsbergSaid
1997
24″ x 30″
OIL AND MARKER

The statements on this picture were some of the first comments I heard after I was diagnosed with advanced breast cancer at age 27. My goal at the time was to live to be 30. Luckily, my youth, stubbornness, and determination got me through: Last October I celebrated my 38th birthday. This self-portrait shows my bilateral mastectomy. I'm wearing a scarf to hide my baldness. The yellow flames at the bottom show my anger, but I outlined myself in green, which makes me think of spring, new growth, and healing. Painting these ridiculous statements allowed me to let go of them.

You're too young *I found a lump at age 26* You have no family history *So* The mammogram was fine *Are you sure?* Come back in 10 years *I'd be dead* It must be a cyst *I don't think so* Let's wait *What for?* You have advanced breast cancer *But I'm only 27* All your nodes are positive *Positive for what?* Your hair will grow back *That's not the point!* You are incurable *As in romantic* You didn't have risk factors *Oops*

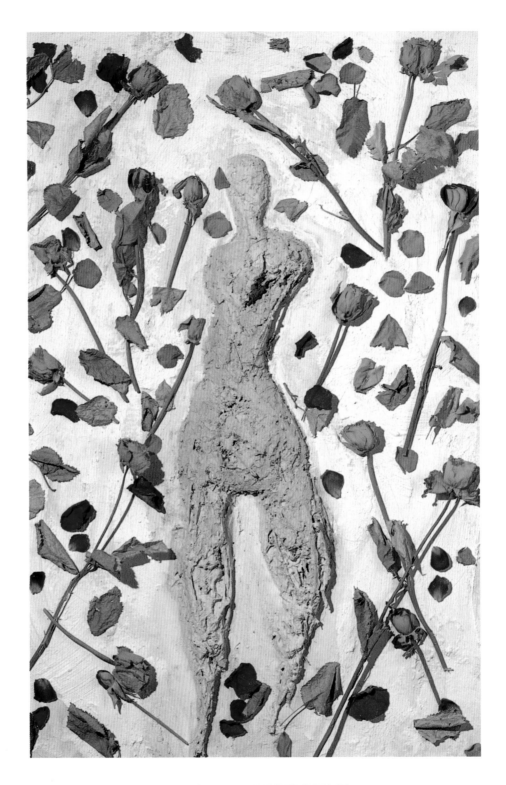

HOMAGE TO A WOUNDED BREAST
Betsy Bryant
1996
16″ x 24″ x ³/₄″
MIXED MEDIA ON WOOD WITH ROSES

Betsy Bryant

I created this figure after my lumpectomy, in a fit of passion and despair over the lost part of my breast. In my breast cancer support group, many of us felt ravaged by this disease, and we grieved for our lost breasts. This figure expressed my despair and loss.

CLASSIFIED

Wanted to fill vacancy.
Due to ill health and eviction,
now seeking new tenants.
Double occupancy required.
Must be portable and flexible.
Team work required.

May require hanging around
for hours at a time.
Must be able to "warm"
to the occasion.

Must act as "bosom buddies"
and work well as a pair.
One must be left-handed
and one required to be
right-handed.

This position is permanent.
Immediate occupancy and
a lifetime contract offered.
Only Saline individuals
need apply.

For more information
phone the BUSTLINE:
4MY-BUST (469-2878)

Carol Sue Holbrook

I created "Classified" in 1993, shortly after having bilateral breast reconstruction with saline implants. I was still psychologically adapting to having "breasts" again. However, the "breast mounds" created by saline implants were much better than a prosthesis that had to be stored in a box at night. Humor has always been part of my coping with life, so I created this light-hearted view.

SEVEN OUT OF EIGHT DON'T

Ana Smulian

1997

16$^{1}/_{2}$" x 13$^{1}/_{2}$"

MIXED MEDIA

I read in the newspaper that a local doctor/researcher had stated that since seven out of eight women don't get breast cancer, it's a rare disease! *Creating this piece helped me deal with the rage I felt about this man's words. The figures, though similar, are different—as each of us is different. The eighth piece is torn apart, signifying what happens when you find out that* you *have breast cancer. The tearing apart of yourself, along with your loved ones, is visiting hell and coming back alive—at least for now. On the eighth figure, an X marks the spot where cancer was detected; the inside is painted red, signifying the blood and pain following diagnosis. A fragmented mirror reflects that this one woman out of eight can be any one of us.*

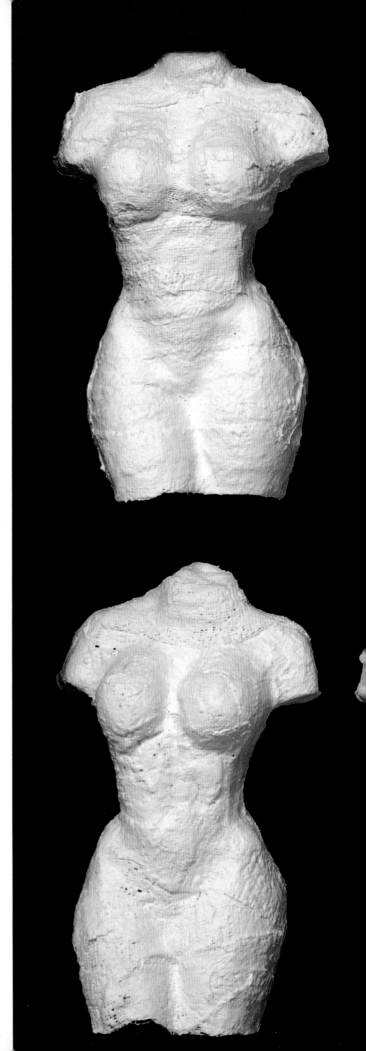

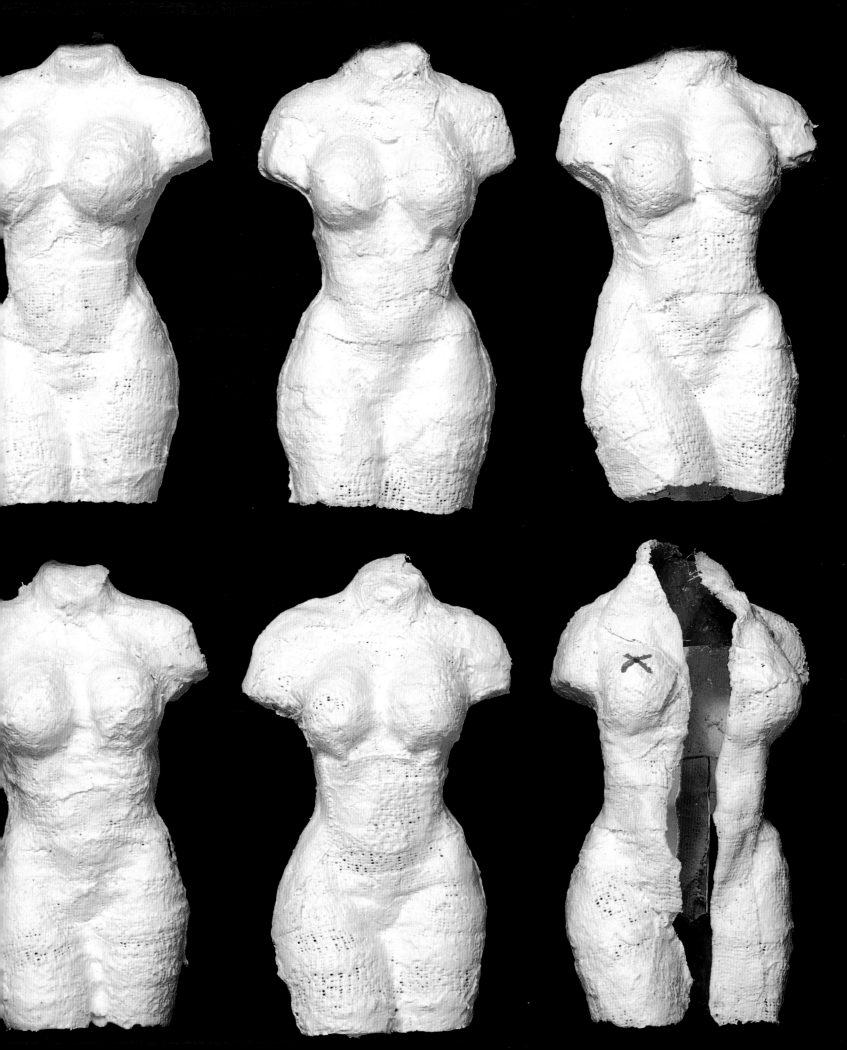

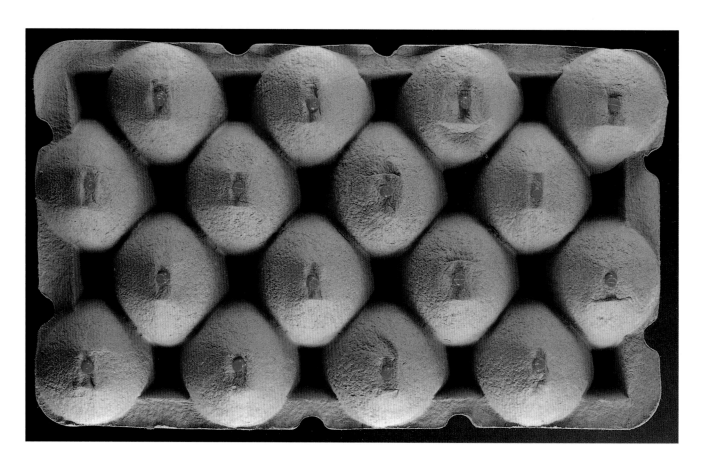

REFLECTIONS
Lila Radway
1990
12″ x 20″
Mixed Media

It was the most serious decision of my life: remove the breast and get rid of the lump and the cancer. It sounded traumatic but simple. After the surgery, I wanted to re-create the breast again—and again—and again—and again—and again. Oh, how I wish it were this simple.

No Neva Mind/It's Mine/I Mind

Wanna Wright

No neva mind?
Y'all (who say y'all love me)
Say it don't make y'all
No neva mind
Dat dey cuts off my titty (OK my breas').
But—I mind.

Is it 'cause y'alls is grown
An' don't need it no mo?
Don't 'member when it fed
An' soothed yuh way back din
Sooths yuh now—when trouble comes.
I 'member (like it was jus' yestidy).

Is it jus' caus' it's old
An' yuh don't wants it no mo?
To feeds yuh ego or what eber it
Fed in da dark or whens dem oter menfolk
Made 'miration' wid dey eyes.
I 'member (like it was jus' yestidy).

Maybe y'all say it don't make y'all
No neva mind
'Cause y'all think dat if it don't make y'all
No neva mind
Dat it won't make me
No neva mind?

But y'alls got another think comin'
'Caus' it was mine
To share wid y'all
And it's still mine
Eben if it ain't good for nuthin'
But keepin' da uder one comp'ny.

Y'all beda lisen an' hear dis
Somebodi got some 'splainin' to do
I ain't lettin' nobody cuts it off
Jus' caus it don't make dem
No neva mind.
It's mine—an' I mind.

Wanna Wright

Bobbi was feisty, she asked questions, tried alternatives, wouldn't "just let them cut off her titty"—and she died. Why? What was she thinking? She said the doctor didn't respect her intelligence. Is that what he said or what she heard? This poem was conceived as I thought about Bobbi. I remembered that during slavery, black breasts were examined on the slave block, owned by the master, and commandeered to suckle white babies, often at the expense of black ones. A woman's breasts were valuable only as long as they were useful to others. I remembered that the doctor did not mention the option of a lumpectomy to me. My family said I should be grateful to be alive. My husband said, "I'm not a breast man anyway—can't handle but one at a time either." Is one of the barriers to early detection that black women believe no one cares about their breasts? Is there a lingering attitude that if you can't pay, you don't deserve to have options? I wanted women to know that they can stand up and say I value my breasts—and that they don't have to die to keep their dignity.

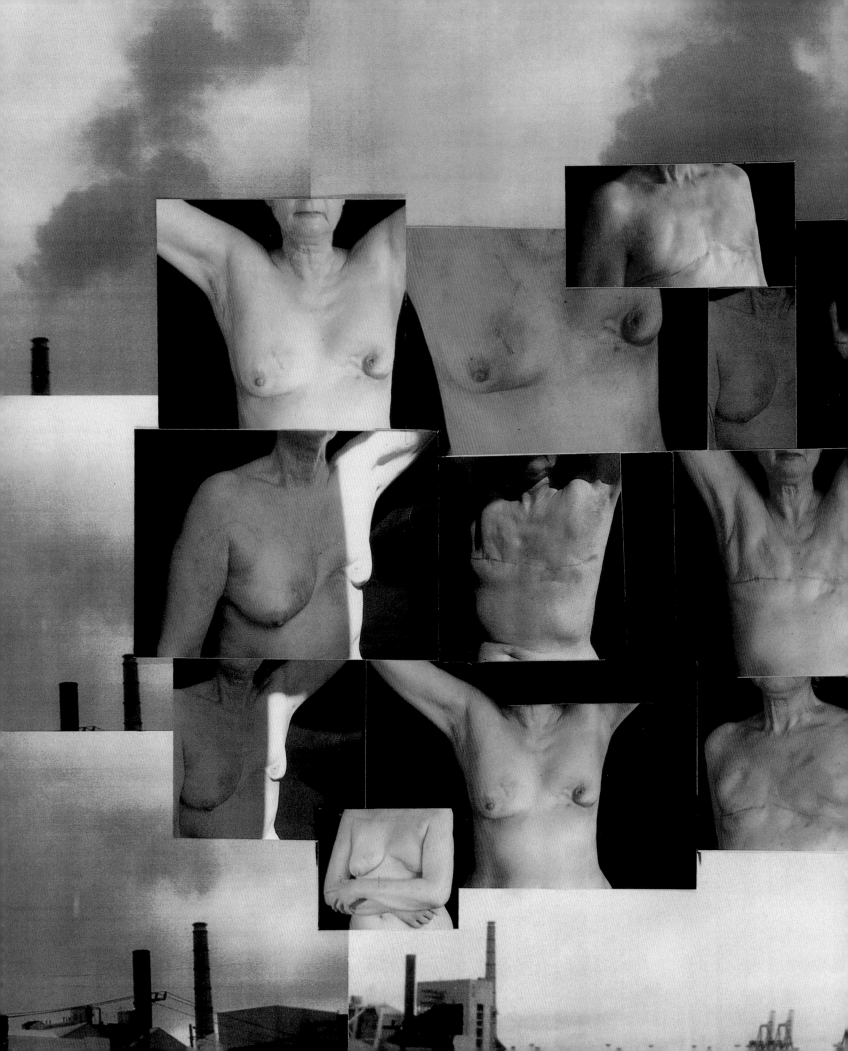

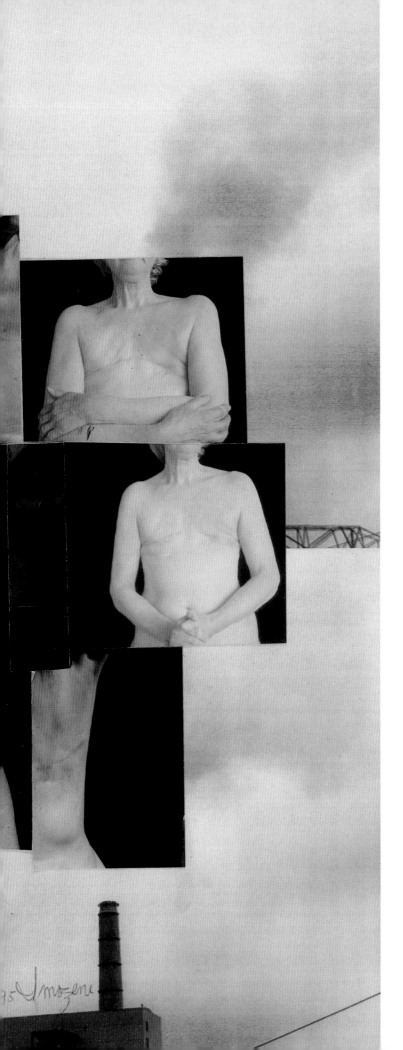

INDUSTRIAL GROWTH
Imogene Franklin Hubbard
1996
25″ x 21″
PHOTO COLLAGE

A fellow artist, Sharin Smelser, took photos of my chest through my year of hell, including the initial lumpectomy, radiation, a second biopsy on the other breast, and bilateral mastectomies. She gave me the photos and told me I ought to do something with them. At the time, I was in a fight to keep a third polluting power plant from being built here on Hunter's Point in San Francisco. I had learned that the polycyclic aromatic hydrocarbons (PAH) in these emissions invariably caused breast cancer in young female rats with estrogen in their bodies. There I was up the hill from power plants that were spewing PAH on me and my neighbors. I took photos of the power plants and enlarged them on a copier, so that the images were not only larger but also less sharp than the originals. I arranged them and the photos of my mutilated chest on a large piece of cardboard, glued them down, signed it, and framed it. The whole process helped me to vent my rage.

ONE IN EIGHT
Diana C. Young
1996
15" x 19"
TONED PHOTOGRAPH

One Saturday morning, I gathered together six of my closest friends and one of their daughters for lunch and a photo session. It was an interesting experience in many ways. We found that every woman's breasts are as totally individual as her face. Everyone agreed that my scars didn't look nearly as bad as what they had expected. After the photos, we were all reluctant to put our blouses and shirts back on since we had all experienced such closeness, honesty, and ease during the shoot. The title of the work is "One in Eight" because the lifetime risk of being diagnosed with breast cancer is one in eight.

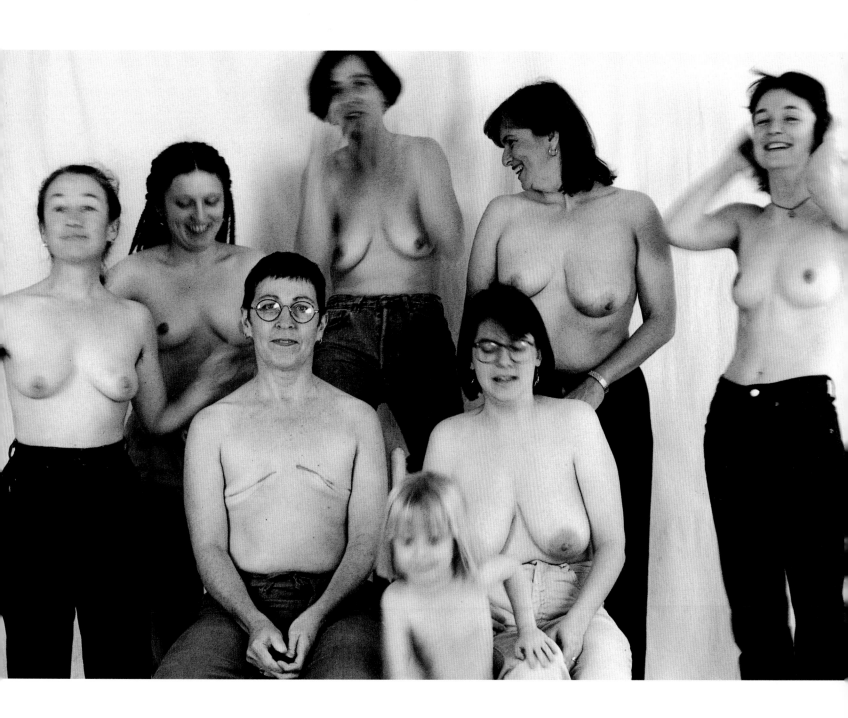

Though the Frost Was Cruel

Patricia Watt

"You're so courageous through all this." People say this to me a lot and it is partly true. The immense courage of ordinary people has always moved me. As my friend Adrienne used to say about her cancer, at each piece of bad news you fall apart and then you pick the pieces up and get on with it. Perhaps that is really what courage is. In any case, there is nowhere to hide.

The truth is that I have moments of courage and moments of sheer terror, separated by long hours of disbelief which act, I am sure, as a protective shroud.

Those times of terror have a way of striking at about 3 a.m. I awaken suddenly, every nerve alert to this threat on my life, a helpless "No" in my throat, my mind full of a futile wish that it all turn out to be a bad dream. "Wake me when that happens," my husband admonishes. "Don't be alone with it." But what can he do? He who has already given so much should have his sleep at least. I weather it alone. I pray a lot. I ask for calmness. I ask to be allowed to see grandchildren. By the time dawn brings first light, I sleep.

On one such night before surgery, when the terrible reality was still fresh, I did wake him. I remember weeping protests against cancer, thrashing about as he sought to comfort. "What can I do right now?" he whispered. "Is there anything I can give you?"

I don't know why, but "sing to me" was what I asked. I lay still then and waited. Softly his sweet tenor reached across my darkness. "Good King Wenceslas looked out, on the feast of Stephen . . ." It was the 25th of July! Nevertheless, it was Christmas.

Patricia Watt

In the beginning, I wrote only for my own healing, a way of being fully in the experience as its meaning unfolded. I shared my pieces first with friends and family, then with a wider circle of women. It was while I was making a tape of poetry for a friend who was dying of AIDS that I knew immediately the medium my pieces wanted. The prose poems included in THE TURTLE STONE: STORIES OF WOUNDING AND HEALING *have found their way around the world.*

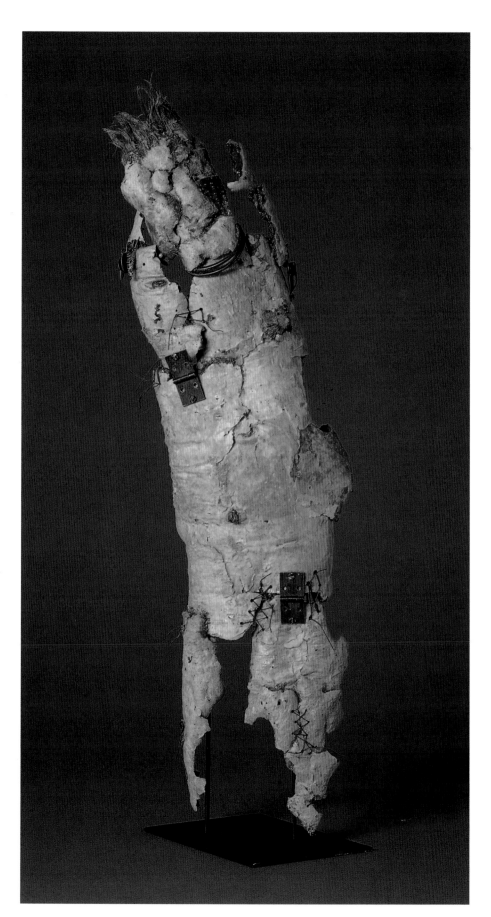

I WAS ONLY 38!
SELF-PORTRAIT
Cecelia Rawlings Thorner
1995
30″ x 9″ x 1½″
FOUND OBJECT ASSEMBLAGE

_It was August 16, 1977. It was the day
Elvis Presley died. A part of me died,
too, that day. It was the day I was told I
had breast cancer._

Breast Envy

Lucy Sherak

I have become an observer of women's breasts
Noting the symmetry, shape, and naturalness
The large woman seated next to me on the airplane
Ample bosoms inflated grotesquely
by air blowing from the overhead vent
On the screen
the movie actress
has perky little hooters
under her modest blouse
My hat tilts rakishly to the right
as does my bustline
My shirt stretched tight
to best advantage
semi-bare one-sided busted chest

Four months after my mastectomy
I went shopping for a new bra
Choking on tears
breast envy and grieving
In every woman
I saw the firm, droopy, round, shapely
Paired breasts
It was so damn hard
I was the circus freak
The left-over devastation
of a personal and shameful war
And the temporary cotton prosthesis
kept climbing up my shoulder
like a misshapen growth
Later a large silicone "breast form" lay securely against my ribs
under my thick mastectomy bra
Pulling heavily on my shoulder
Jiggling when I walked
And every evening
a new surgery
as I removed the body-warmed quivering mass

Audre Lorde said that
when women hide their mastectomies
they lose the ability to identify each other
and form alliances

I wear a button saying "Cancer Sucks"
in place of my absent breast
And the silicone "breast form"
lies motionless
in the back of my drawer.

Lucy Sherak

Two years ago, I was thrust into the frightening uncertainty of the world of the breast cancer patient. I began a journal to record the events and feelings of this world, and a year later, I found myself writing intense, angry poetry. I have found in my poetry expression for my rage and fear and grief and hope. "Breast Envy" was written on an airplane. I was reflecting on the pain I had felt at the loss of my breast and the strength I felt—and still feel—as a woman in the battlefield with her comrades. I was feeling cocky and sure of myself.

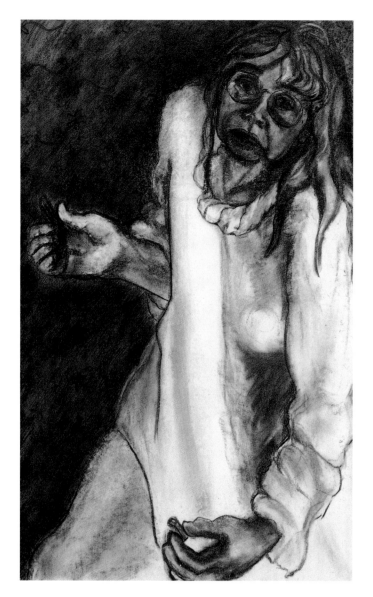

SELF PORTRAIT
Ria Orans
1986
45″ x 31½″
CHARCOAL ON PAPER

I was diagnosed with breast cancer in the late 1970s. All my life, I had worked hard and done what I had to do. I decided that if I had only five years or maybe less, I would go to art school, something I had always dreamed of doing. There I acquired the skills to express my experience with cancer. This self-portrait was drawn in 1986, five years after my mastectomy. I was contemplating what I had lost, but I was also grateful to be alive. Time has become more precious to me, giving me greater concentration and focus. Also, I have been able to participate in the development of my grandchildren and to pot and paint for twenty additional years.

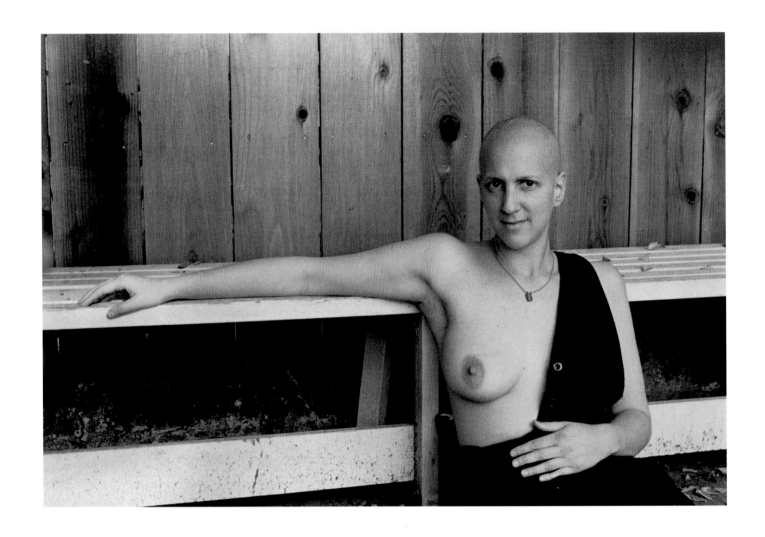

MY CANCEROUS BREAST
Anita Bowen and Nava Frank
1995
8″ x 10″
TONED BLACK & WHITE PHOTOGRAPHS

When Nava was diagnosed with Stage IV cancer at the age of 31, she undertook a personal journey to come to terms with the disease that has haunted the women in her maternal lineage for over three generations. Anita Bowen was interested in using her photography as a vessel for healing and to bear witness to the strength of the human spirit. What emerged was a two-year collaboration. We created images to capture what words could not. When Nava lost her hair, she felt surprised and frightened by her new appearance. These photos show how the cancer affected Nava's image of her own sensuality and sexuality over time.

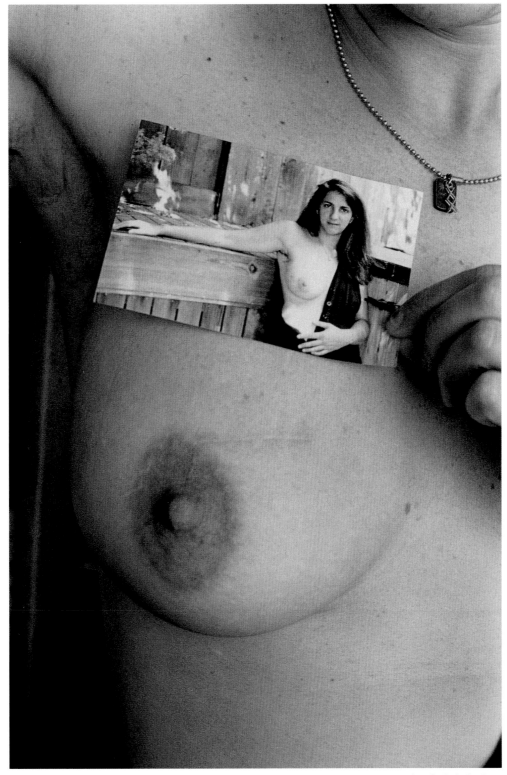

Inset photo by Catherine Ames

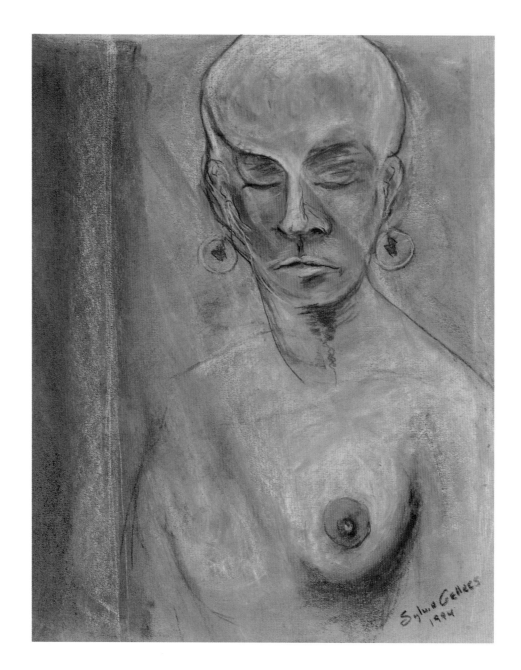

REFLECTION

Sylvia Colette Gehres

1995

32" x 26"

PASTEL

*Looking back at me in the mirror was this bald, one-breasted woman. I had
to get used to this strange new head and body, so I put it on paper. It is easier
to look at the picture, which is once removed from the reality. The earrings are
important because they were favorites in the years "before the cancer." They
function as the "familiars" in the piece.*

Double Amputee

Lois Tschetter Hjelmstad

I have looked this way
Before—
Flat-chested, pencil-thin

When I was ten

Strange it is to seem
A sexless child
Again

(Too bad about
The graying hair
And slightly sagging chin)

July 1991

Lois Tschetter Hjelmstad

The night before my first mastectomy, I wept as I wrote a good-bye poem to my beautiful breast. When I finished radiation therapy, my therapists received a farewell in poetry. Later, my emotions continued to spill onto paper as I began to realize the impact that a life-threatening disease was having on my life. I confronted issues of body image and self-esteem, changing relationships, compromised sexuality, reordered priorities, and fear of recurrence. I committed to being totally honest with myself. As the poems evolved into a book, I was passionate about continuing that honesty. Poems of mine that appear on these pages are excerpted from FINE BLACK LINES: REFLECTIONS ON FACING CANCER, FEAR AND LONELINESS.

SURROUNDED BY ANSWERS

Virginia Stearns

1997

22½" x 30"

Collage

After my breast cancer lumpectomy in January 1996, I plunged into months of research and found myself faced with an overwhelming amount of information, much of it conflicting. Although I had made my major treatment decisions by the time I started this collage, I still wondered if I had made the right choices. I needed to express how overwhelmed I felt, but more, I wanted to make sense of this profusion of viewpoints, find the broader picture.

A Brief History of My Breasts

Pamela Roberts

December 1993

"Your breasts will start developing now," my mother said when I was 11 and started my first period.

I waited.

At my mother's urging, we went downtown to Leh's department store to buy my first bra. I was still flat as a board, but since seventh grade gym meant undressing in the girl's locker room where everyone wore a bra except Norma Schlieben and me—and Norma Schlieben was clearly a nerd—I acquiesced.

In the lingerie department I felt like an impostor. Racks of lacy brassieres pointed their large wired cups at me while my mother and the salesclerk talked much too loudly about my fate. They decided on a training bra for my first bra, although I never could figure out what I was in training for. It was a cupless, smooth halter of stretchy material that would mound out as I grew into my glory. Like Debby Peters filled out her cheerleader's uniform, I, too, would someday—soon, I hoped—fill out my bra.

I waited.

I wore my harness faithfully, my uncomfortable prison of womanhood with shoulder straps that dug in and elastic that encircled my flat chest with nothing to keep it in position. The bra would hike up and I would yank it down.

I waited.

In my freshman year of college a girlfriend took me to a doctor in Collegetown who gave out these amazing new things—birth control pills—no questions asked. As I swallowed the little white pills that catapulted me into the '60s, my newfound experiences of sex without fear of pregnancy were coupled with an interesting side effect—larger breasts! I could actually fill out an A cup without wrinkles of cloth interrupting my silhouette.

By my junior year, I had simultaneously embraced women's lib and gone off the pill due to reports of possible long-term side effects. My breasts were free at last! Their tidy, unfettered selves bumped bra-less and unencumbered under gauzy shirts and tank tops. Freedom was in my body and in my soul. At a student rally, I stood up to speak, exhorting us to take action, to march, to stand up for our rights! The response to my speech was embarrassingly minimal.

"When you spoke, your nipples stuck out through your shirt," a male friend said to me afterwards.

Another fine spring day a student approached me as I sat in the sun on the quad.

"Why don't you wear a bra?" he asked, staring at my chest after a brief introduction. "Is it a political statement?"

"Well, actually," I replied, "it's just more comfortable."

I'll never know, of course, but I imagine that these little breasts gave me just as much sexual pleasure as larger ones would have. A nipple is a nipple no matter how large a lump it crowns. I imagine they gave their fondlers pleasure, too. I remember nights in the tropics with Michael, swimming in the warm Caribbean, the breeze tittering the palms, the ocean licking the sands.

"I love these breasts," he said in the moonlight. "They're a perfect handful."

In pregnancy I wore a bra gratefully. When my milk came in, it held two hard, hot hurting bowling balls affixed to my chest. Where did they come from? Whose body is this? I wondered.

On many a cold winter's morn I cradled my firstborn in my arms in the squeaky wooden rocker and he nursed as the sun rose orange through the river's mists below. The second baby, born during a heat wave, took her first sucks bare flesh against flesh, our sweat mingling in the mother-child rite.

And now, childbearing years barely behind me, my breasts sagging and smaller still, I find that my left breast is an endangered species. It has cancer and, just as the diseased branch is cut off to spare the tree, so will my left breast be removed to save me.

I will be reborn. From the shell of the double-breasted woman will arise a single-breasted Amazon, replete with all the power, strength and abilities a woman warrior needs to survive.

I look at myself in the mirror. How will I look as a one-breasted woman? I cover my left breast with my hand, squishing it into my armpit, and gaze at my reflection. I finally appreciate absolutely being so naturally flat-chested. Dressed for most of New England's days, I will not look any different.

I would like to honor my left breast in its last days. The breast over my heart, the breast that gave me pleasure and nursed two children, is going to sacrifice itself for me. It will leave so I can have a chance to live the long and healthy life I desire.

Thank you, my dear left breast, thank you.

Go with love.

Pamela Roberts

I was diagnosed with breast cancer on Friday, December 3, 1993. The following Wednesday, I went to my weekly writing group and started writing about breast cancer; I have not yet stopped. Of all the healing endeavors I have engaged in since my diagnosis, I've found my writing to be the most satisfying and transforming. Also enjoyable, for I have found some humor and laughable absurdity in the cancer experience.

THE MASTECTOMY QUILT
Suzanne Marshall
1992
64" x 52"
TEXTILE

After my bilateral mastectomy, I became alarmed by stories of women who found lumps in their breasts but avoided treatment because they feared disfigurement. I was also concerned that many women do not realize they have a choice about implants and cosmetic surgery. It is not necessary to conform to society's image.

The story of the quilt reads from left to right. A healthy, whole woman walks along with everything right in her world. Then she gets a mammogram. She receives a diagnosis. She has the surgery. After her recovery, she goes back to the doctor, who asks if she would like to have more surgery for implants. She says no!

The message of the quilt is enjoyment of life amid flowers and music. Fear of disfigurement is no excuse for postponing a mammogram. A changed body is not important—life is!

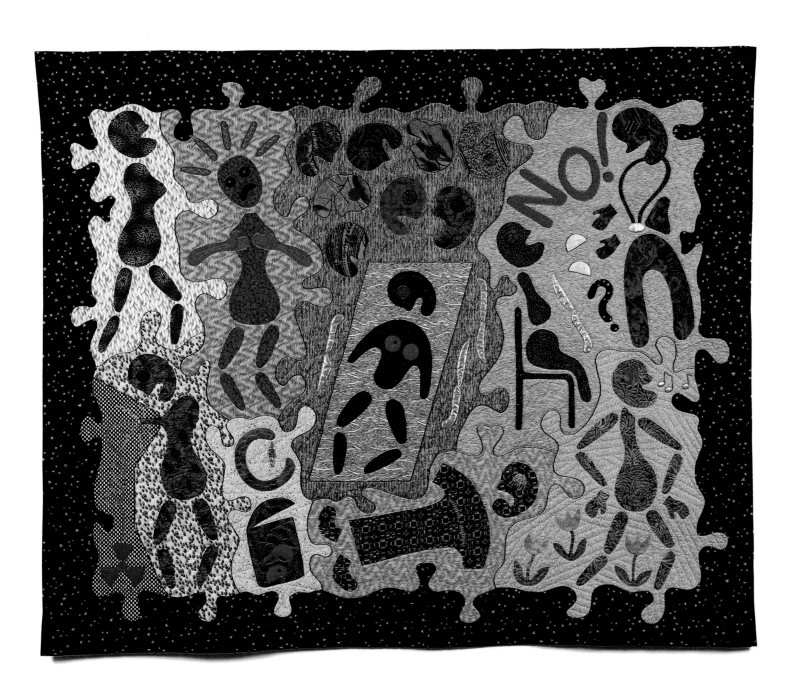

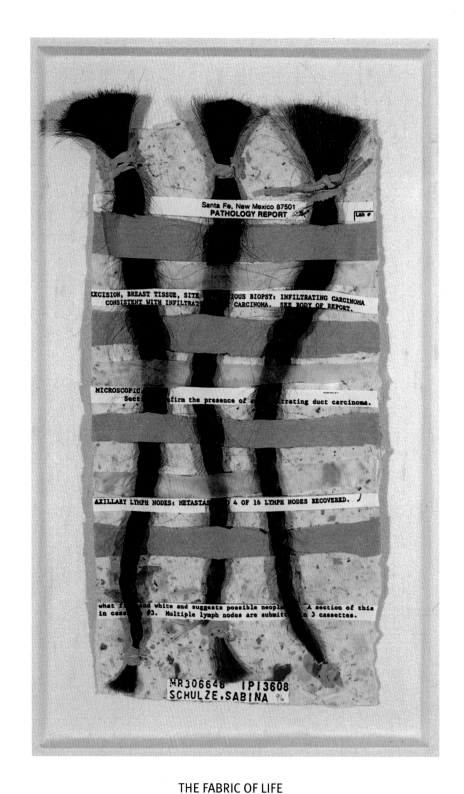

Santa Fe, New Mexico 87501
PATHOLOGY REPORT

EXCISION, BREAST TISSUE, SITE ... IOUS BIOPSY: INFILTRATING CARCINOMA
CONSISTENT WITH INFILTRAT... CARCINOMA. SEE BODY OF REPORT.

MICROSCOPIC ...
Sect... firm the presence of a ...trating duct carcinoma.

AXILLARY LYMPH NODES: METASTAS... 4 OF 16 LYMPH NODES RECOVERED.

what ... and white and suggests possible neopla... A section of this
in cass... #3. Multiple lymph nodes are submit... 3 cassettes.

MR306648 IP13608
SCHULZE.SABINA

THE FABRIC OF LIFE

Sabina Schulze

1996

12" x 18"

COLLAGE

Journey

This collage was created so I would never forget the experience of chemotherapy. To commemorate the loss of my hair, I used it in my art. To remember my fear, I added the cut-up sentences of my pathology reports. To remember several surgeries, I cut latex gloves and surgical gowns into strips. And to remember the gift of friendship, I glued all these pieces onto handmade paper a friend had given me. These objects are forever part of the fabric of my life, reminding me of the threat of metastatic cancer. But they are also a symbol of my creativity, my inner strength, and my power to transform.

—Sabina Schulze

TRIUMPH OF SPIRIT
Susan B. Markisz
1993
16" x 20"
SILVER GELATIN PRINT

I met Phyllis shortly after her diagnosis of breast cancer in 1993. Her sense of humor was evident even in those first dark moments. "I'd better slow down," she said, laughing through her tears. "No judge is going to believe breast cancer as my excuse for getting three traffic summonses in one day." Phyllis had rows and rows of cornrows surrounding her beautiful face. When she began chemotherapy, they started to fall out, until she could no longer tolerate it. She called me just after her trip to a barbershop, where she told the barber to "shave it all off." As she was leaving the shop, a man passed her in the street and said, "Hey, sister, I like your hair!"

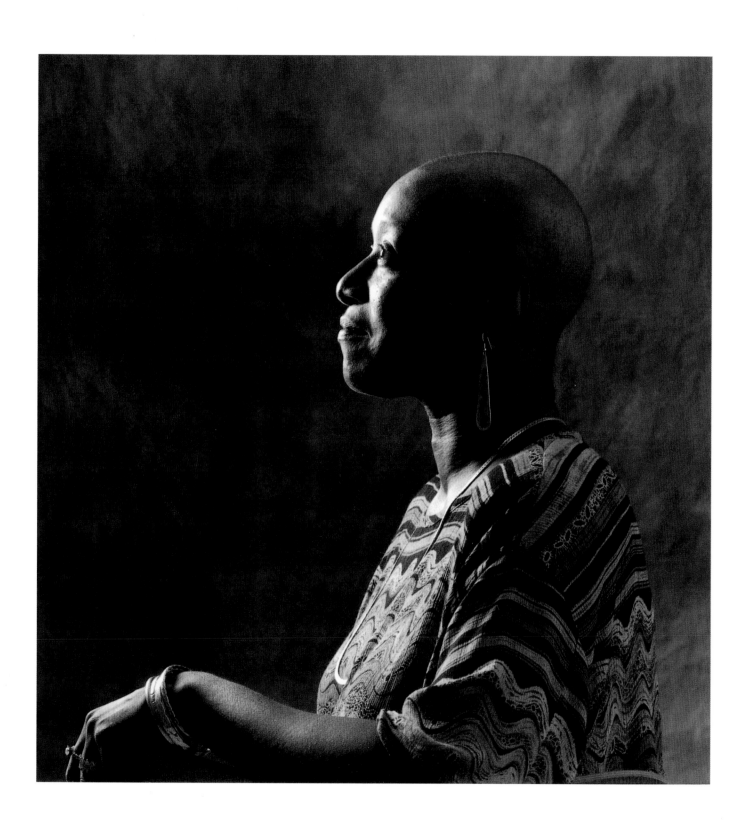

ARMS AROUND YOU

Matuschka

1993–95

16" x 20"

BLACK AND WHITE SILVER GELATIN PRINT

I have always used my body as my main medium. When I got breast cancer, I was inspired to produce a series of public service messages. Although I am not a proponent of mastectomies, I tried to make images that would support those who have had this surgery. I wanted people to be more comfortable with the whole business of mastectomy and created pictures that had a sense of humor. Humor also has a great healing effect and strengthens our immune systems.

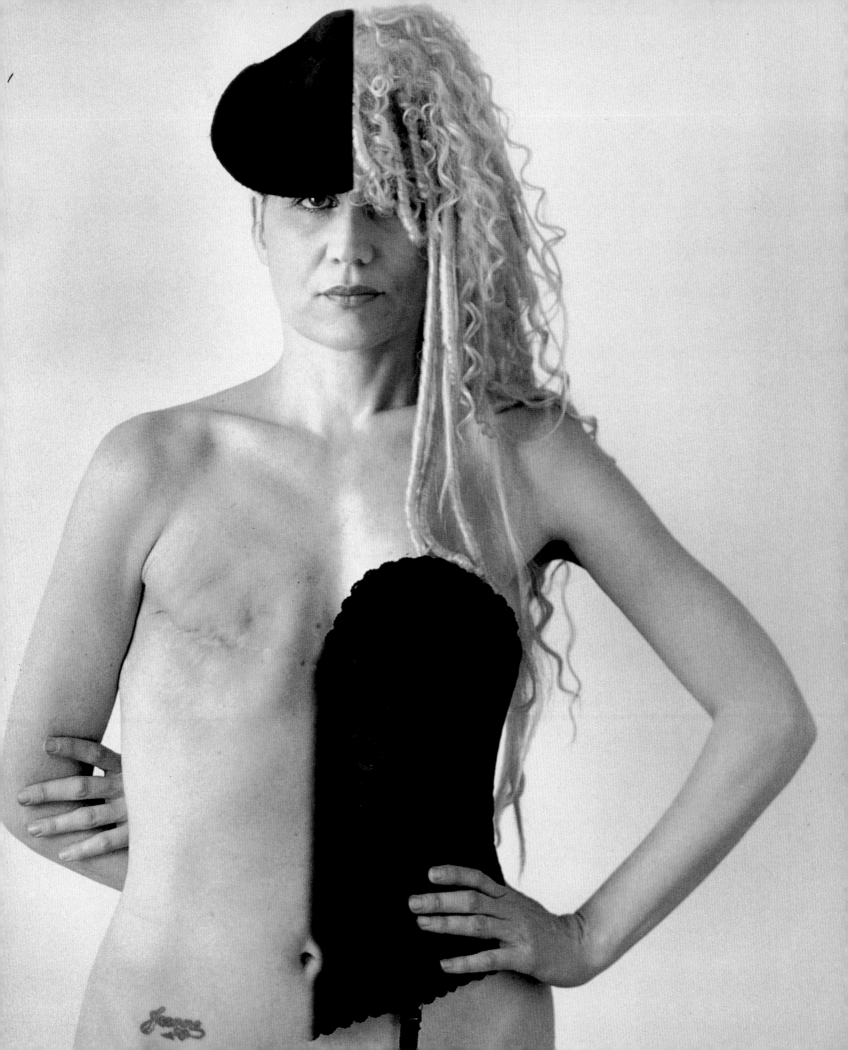

WE ALL HAVE OUR DEMONS . . .
Barbara L. Peterson
1996
23″ x 41″
TEXTILE: QUILTING AND SILK SCREEN

1997 was the fifth anniversary of my breast cancer surgeries and, more important, of my being a breast cancer survivor. My prognosis is excellent, and I have definitely gone on with my life. However, my breast cancer experience is not something I can put behind me or forget about. It is part of the person I am now. Every day something reminds me of that experience or helps me realize how fortunate I am to be healthy and alive. This quilted work displays some of the fears or demons that haunt me in the night, one of which is the possibility my cancer will come back. Addressing my fears with art does not heal as such, but it does help me cope and keep my balance. I am convinced that time is not the great healer it is supposed to be.

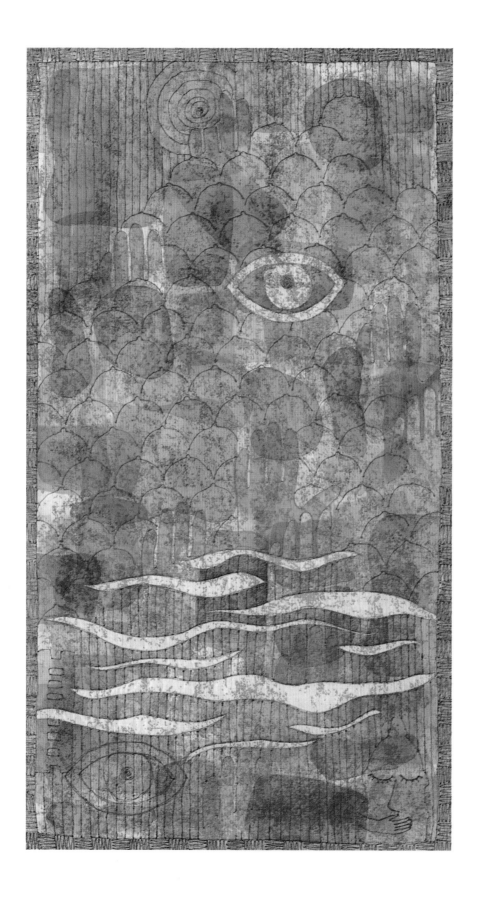

Merijane Block

I began keeping journals in my sixteenth year. In 1989, writing became my spiritual practice and I committed myself to it daily, even if only for ten minutes. So when I began my relationship with cancer, in the fall of 1991, I wrote about it, even when I started out writing about something else.

Writing was my lifeline to myself, my way in and out of the terror and complexity of my life and its new set of circumstances. When I awoke at three in the morning and couldn't sleep, I wrote through the fear until the sun came up or until I got tired enough to sleep again. Faced with impossible decisions, I laid them out on paper, complete with all the anger and sarcasm they inspired in me. Thousands of miles from my mother, I learned to mother myself with stored-up compassion revealed by my daily writing.

I wrote alone and I wrote with friends. My notebooks kept me focused while everything was blowing apart inside of me and around me. My writing kept me whole.

13 December 1991
The Story of the Foghorn

(Recovering from Surgery #1)

Merijane Block

Last night.

Flattened by surgery and sadness, sobbing her worry into electrically-toasted flannel sheets.

He said, I'll turn out the lights and be with you, listen to the song of the foghorns, it's a sweet song.

She listened to him and the horns, stopped noticing the sounds of cars and trucks, heard only the ocean symphony, thought briefly, This is the way out of worry, listen to only one voice at a time, and you can choose it . . . then fell asleep as quickly as she did when they slid the anesthesia needle into her vein only a day before.

Today.

It might be easier.

Listening to the foghorns cleared her head. She knew what she wanted, what she needed, what would make the day easy and kind.

Shedding her clothing for the first time since coming home from surgery, she carefully lowered her unbandaged parts into hot water. Gently, fearfully, she loosened the taped dressing with the edge of a washcloth dipped in hot water, being careful not to drip water on the nipple, where the wound would soon show itself. It took some time and she did not hurry. She stopped a few times and wondered if she should do this work with a friend's help. No. It was hers to do alone, however it was best for her.

Freed from gauze, her breast emerged intact, surprise, dyed yellow from the betadine. ("Prep her breast carefully," she remembered hearing the surgeon say as she counted backward to oblivion. These were his only kind words.) Nipple flat but all there, then a blue-black line of blood behind strips of tape, the line following the circular contour of her areola almost halfway around the nipple, then traveling upward into her breast almost one-quarter inch.

Shock. Sadness. To see this beautiful piece of her body bisected by a thin dark line of blood. Lowering herself into the water, left breast kept above the surface, she breathed and let herself just rock in the bath's gentle current, taking it all in, breathing some of it out.

When she left the tub, she cried.

We let them cut our bodies because we have been told it's best, it's the wisest thing to do, because we are afraid of what will happen if they don't; because we can't *yet* trust our own voice which says I know there is another way. This is the wisdom we have always had, these are the mysteries we have always known; *their* knowledge and skill is new, yet it dominates. To listen to our own voice and not hear theirs— and all the others—is no easier for us than refining our skills so we can only hear the foghorn.

But think of this—that horn is the one clear and true voice that cuts through the fog, that silences cars and trucks, that mutes the excitement, the violence on city streets. And it, too, has been here longer than these newer, louder voices. It is the gentle guide for confused navigators; it is the reassuring song that brings them home.

With the patient in the su
adequate light general
breast was prepped u
draped in the usual
curvilinear ein inci
palpable mass Circum
raised a e dis
to the pectoral
mass was in th
closest to
Therefore, mo
area to assure ck
malignancy
malignancy the me
tumor involvement. Th
irrigated with copious
saline and the biops
using surgical clips
was infiltrated with
was closed in two lay
tissues were reapproxim
interrupted 4-0 monocry
reapproximated using 50
subcuticular fashion. S
were applied. The patient
and was taken to the

PHYSICIAN'S REPORT II
Violet Murakami
1997
3½' x 2½'
MIXED MEDIA, COLOR COPIER PRINTS,
MICRO SLIDES, ACETATE

Although I felt a lump in my left breast one day in December 1995, the mammograms came back normal. But by early 1996, I was diagnosed with breast cancer. Since then, I have undergone several operations and a round of radiation therapy. I used visual representations to express emotions that I could not put into words. This work is part of a larger installation that used computer-generated images combined with text from a physician's report, bone scans, microslides, and acetate.

on the other side of the bed (for Debbie)

Lucy Sherak

She sat, my friend
crossed legged hunched over
spitting blood
breathing shallowly
as she waited for the transfusion
STUNNED
by the magnitude
of dismal medical reports
revealing the unyielding progression
relentless invasion
metastatic cancer
of the breast
lungs filling liver darkened
how immeasurably bad
is bad news
reaching for my hand
apologetic
suspended in disbelief
This must be hard for you, she quavered
a lone tear in the corner of her eye
I smiled and choked back
squeezing her hand
Yes, but wouldn't you rather be
on the other side of the bed?

Lucy Sherak

*This poem records a gut-wrenching moment, as I saw
my friend slip further away, destroyed by metastatic
breast cancer. We were diagnosed two days apart. She
died a few weeks after I wrote this poem. Ironically, I
am now fighting metastatic disease and struggling
very hard to stay out of that dying bed.*

22 April 1992

Merijane Block

Everything takes longer
than you think it should
or thought it would.
Except your life.

Merijane Block

*This poem came to me exactly one week after
my second surgery (there were four). Six years
after my first diagnosis (there have been three),
I speak it to myself at least once a day. It's
still true.*

TREADING THE MAZE
Susan E. King

1993

$7^5/_{16}''$ x $8^1/_4''$

DOUBLE SPIRAL, XEROX, OFFSET

EDITION 800

When I was diagnosed with early breast cancer in 1989, I began a journey into the land of cancer, a foreign country with its own language, one that focuses on borders and edges, location and site. Part of my regular job is to push the content of art into new territory. With this illness, my job seemed to be just the opposite. I needed to focus on containment of the border cells. I had entered the true borderland. This artist's book follows the structure of the maze at Chartres Cathedral in France. Readers/viewers, in the role of pilgrims, are confronted with unexpected images, stories that look back and forth in time, and a sense of what it means to walk into the maze of illness and back out again.

Force of Habit

Lois Tschetter Hjelmstad

Once before we went to sleep
my husband reached
to caress my missing breast—
I felt him cringe
and he slowly
withdrew his hand,
hoping I had not noticed.

Having done so once,
he never forgot again.

I learn more slowly.

Whenever I run up the stairs
my hands instinctively
fly toward my chest—
forgetting, after all this time,
there is no need to steady breasts
that lie on the cutting room floor.

March 1993

Lois Tschetter Hjelmstad

*Sometimes I am ambushed when I least expect it. Sexuality
has always been an important part of my life. Breast
cancer has compromised that physically, emotionally,
and spiritually. I am adjusted. I am not reconciled.*

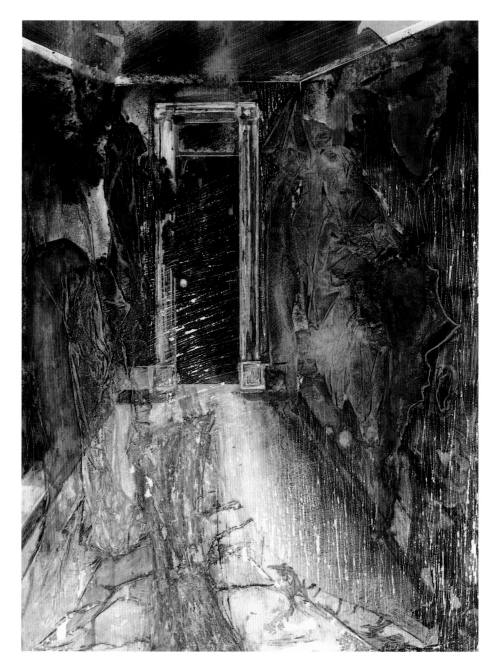

THE PATHWAY IS NOT THE DESTINATION

Nancy McCracken Morgan

1996

21$\frac{1}{4}$" x 28$\frac{3}{4}$"

Watercolor Collage

After my diagnosis, I had so many unwanted decisions to make: radiation . . . chemotherapy . . . surgery . . . wait and see. I began to make sketches of this experience, showing a dark windowless hallway. At first, there was no hope. The door knob would not turn. Then I found an oncology surgeon who was kind and understanding. He not only answered my questions, he also wrote the information and drew diagrams on the examining table's paper cover. I planned and redid my painting while waiting for my body to recover from surgery. Now the door at the hallway's end was open, and a little light shone through from the other side.

For the Time Being

Elizabeth Hurst

Once I lived in the peace
of orderly flesh, clean cells
meshed, easy in the routines
of forty-five years, until one
morning in the shower in
barged the star of this whole
show—like Jayne Mansfield
it's all tit, pure girl material
gone wild, a hideously high-
priced piece of cheese; a nasty

little octopus sunk comfortably
in my right breast. It's gone
for now, but the other-worldly
DNA still reproduces itself in
the pattern of my life—six
months of complete weirdness,
polygamous with specialists,
shining with murderous light
and chemicals. Right now

I'm spending time inside this
dwarfish simulacrum of a living
room—it's thick with chilled
air, as though a drop of degree
could halt the rot; New Age
books cover shelves, celebrate
the high of dying, while black
rows of videos preserve heroic
journeys into some poor fuck's
innards. My nipples tighten as

a brand new stranger discusses
the guilty tit and its bad, bad
daughter. Nothing in my heart,
brain or crotch manufactured
this cellular slut, but I'm more
responsible than one hundred
chapters of the P.T.A. The white
lab-coated voice greases me up
with compassion—I clench every
muscle—I can't stop wanting to
live; so I say, Yes hit me with
light, poison me, it's only six
months in exchange for maybe
twenty years; arithmetic binds
us; now do whatever can be done.

Elizabeth Hurst

*Cancer is a complicated gift, unasked-for and
undeserved. Imported from the rich mines of
the underworld, it sheds metaphors and ideas,
as well as murderous cells. Cancer is also a
generous disease. It has brought me horror, rage,
and loathing, along with empathy, courage,
poems, and an almost unbearably sharpened
sense of life. It is time's Philosopher's Stone,
and a meteor flung up from hell; a serial killer's
wet dream, DNA's idea of a joke—a squirm-
ing handful of chaos which I may or may not
still own.*

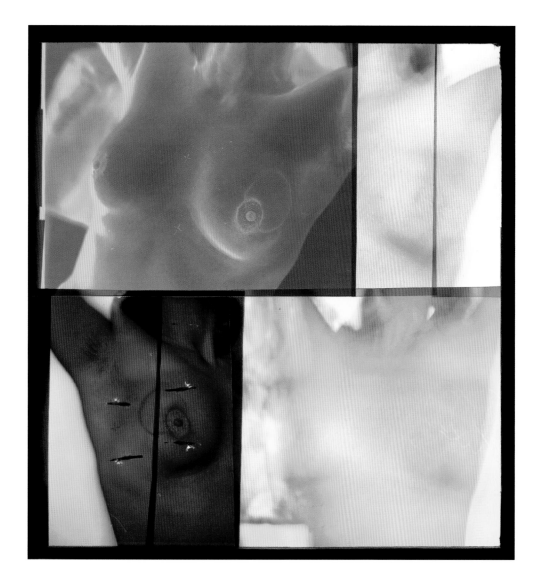

RADIATION COLLAGE
Kit Morris
1997
16″ x 20″
R-PRINT

Perhaps because I am a professional photographer, working around equipment every day, I wasn't as disturbed as some women are by the machinery involved in radiation therapy. In fact, I was intrigued by the marks they use to focus the lasers, especially the periwinkle blue circle around the booster site. Color can be very seductive. As part of my healing process, I photographed the effects of radiation on my skin: the tattoos, the boost circle, and the sunburn. Some of the images were beautiful whereas others were shocking. Having cancer is shocking, but surviving it is a beautiful experience that I am thankful for every day.

"It's Gone Round the Bend"

Mary P. Milton

My grandmother pronounced
whenever her great nose probed
containers left too long
in the refrigerator

As a child, I pictured
a sunwide stream
between obeisant trees
flicked by iridescent dragonflies
arced by bird and cricket calls

Then the turn to gray silence
raven crags, sluggish water
bearing the barge with the body
of Elaine la Blanche
Fair Maid of Astolat

Now I discover
my left breast's gone
round the bend

Mary P. Milton

"It's Gone Round the Bend" is part of a collection I wrote as an expression of gratitude to friends who supported me during my experience with breast cancer. Their caring and willingness to help were delicious lemonade. Sometimes, I think, we don't realize how wonderful and how strong everyone—including ourselves—can be until something bad happens.

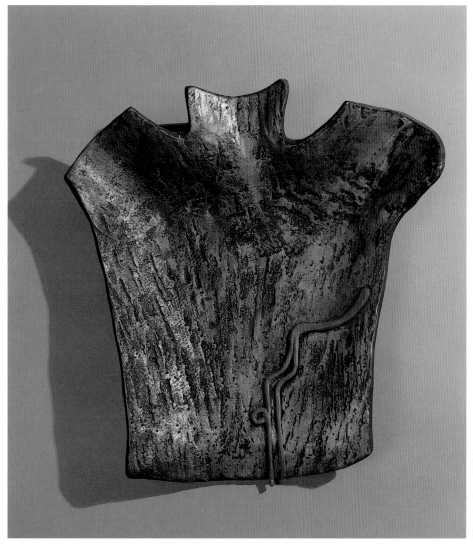

ME
Marilyn Kaminsky Miller
1997
16″ x 16¼″
CLAY, STAINS, AND ACRYLICS

Radiation treatments are given daily for several weeks. To make sure your body is in the same position each time, a mold is made of the area around the part being radiated. This piece was made from my radiation mold. Not knowing what the radiation treatment would feel like, I was extremely scared the first time out. I felt nothing. When the treatment began, I was entranced by the beauty of the pattern the laser light reflected from my body back up to the machine. The red lines on this piece are one of the patterns I saw.

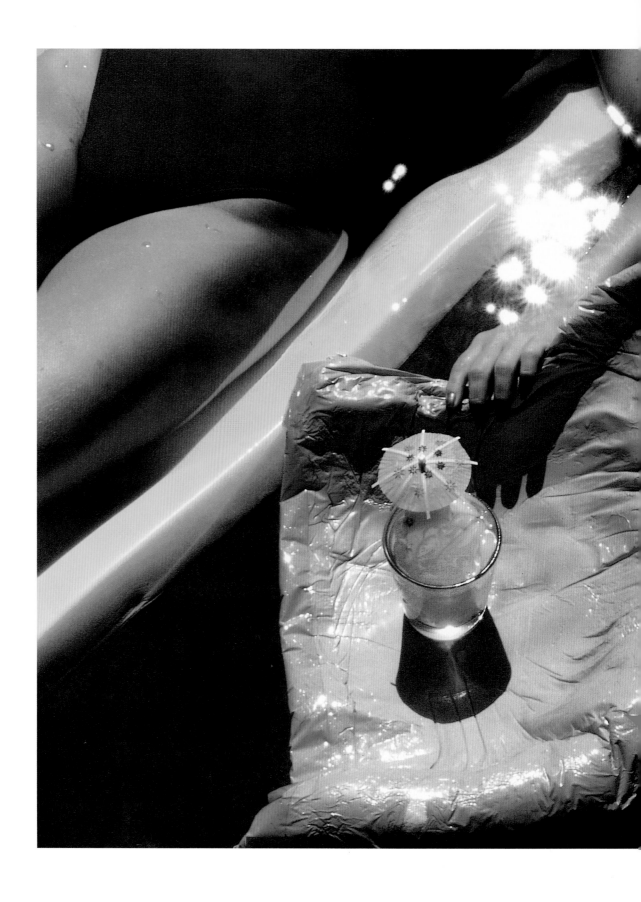

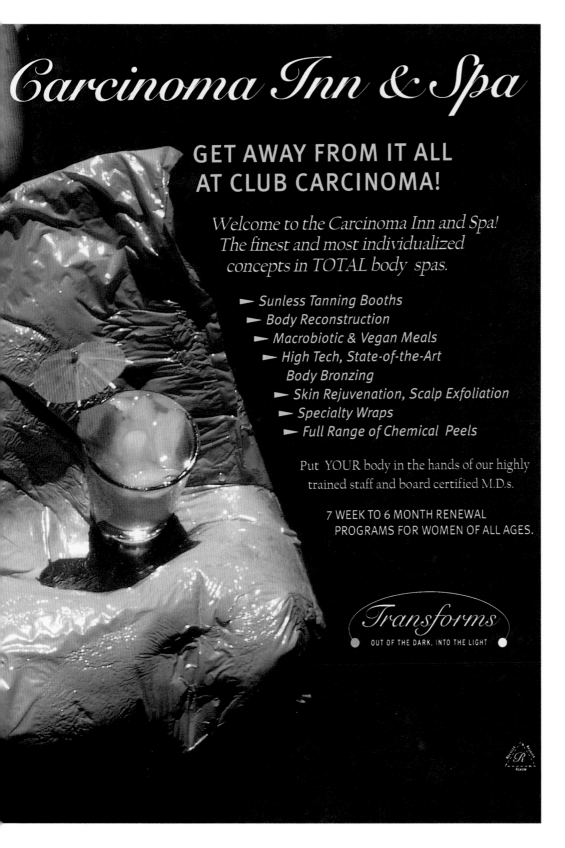

BLUE BAG AD CLUB CARCINOMA
Transforms
Elyse Eng, Brenda Eno,
Jody Mahoney, Kit Morris
1997
20" x 12"
Iris Print

The Blue Bag Ads are a collaborative effort by four women who met at a Movement/Arts group for breast cancer patients, offered by the Institute for Health and Healing in San Francisco. We wanted to take part of the cancer experience, the mold used to position a women's body during radiation therapy, and see it in a different light—out of context and with humor. There is a definite edge to this ad. It looks like it could be from any women's magazine, publications that bombard us with images of beauty and perfection. What if, as we flipped through these magazines, we found big, glossy ads about breast cancer?

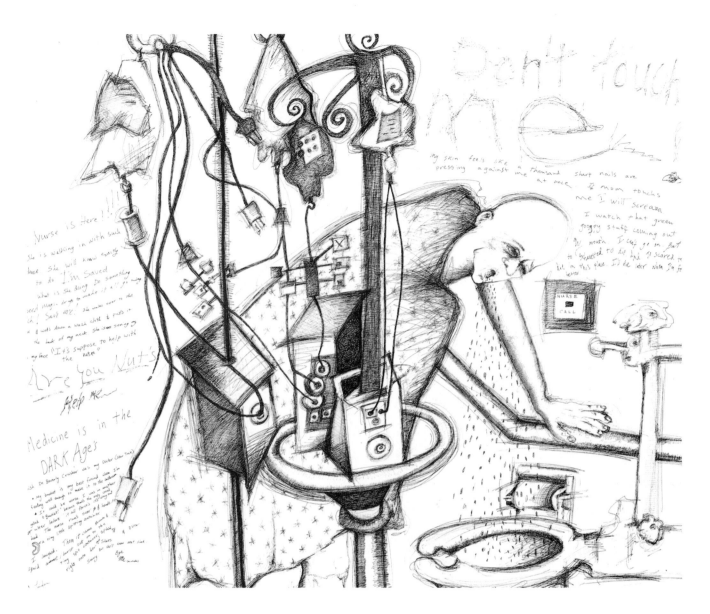

"DON'T TOUCH ME"

Arlene G. Linder/Michelle Lee Linder

1996

32" x 40"

Pen and Ink

During the month of May 1994, I discovered that my daughter had breast cancer. We were told that it was moving so fast she would be lucky to live 6 months. What followed was a year of agony for our whole family, but most of all for our very brave daughter. In this drawing, I stare through the bathroom door, wanting to hold my daughter in my arms. But she can't stand to be touched—everything hurts. Her eyes meet mine, and they say "Mommy, stop the hurt." The only thing I can do is reach for my drawing pad. I am helpless.

Returning Calls

Rella Lossy

I will not return their calls.

Traveling through radiation,
through chemo,
I roam in a country
whose language does not translate
across boundaries;
my itinerary, freakish;
my emotions
open, strewn, scattered.

No one else can help me anyway,
with their damned success stories,
their you-can-do-it smiles.
I will not return their calls.
How do they know I can do it?
Do they think I know I can?

I hate the miracle books
friends send—
wheat grass, coffee enemas,
guided imagery, God—
I want to burn shelves
of snake-oil promises,
won't meet
with a "victor," "survivor,"
whatever she calls herself,
the one wearing
hat, make-up and jewelry,
while I clutch my dirty bathrobe
wondering how I can
live through the next fifteen seconds.

I will thrash against them all,
I will not reach for the phone.

Rella Lossy

Rella Lossy had written poetry for nearly five decades, but the volume called TIME PIECES *is her legacy to those who survive her. After an enormously revitalizing week at the Commonweal Cancer Help Program, she experienced a burst of poetic creativity. The poems record her struggle with a widely metastasized breast cancer.*

Chemotherapy

Ellen Goldsmith

Tired is a cape in the night—
dark, heavy fur whose warmth stifles

Tired is a long tunnel—
damp, with no lights and sudden turns

It's the woods, windy
and full of sounds of animals, rustling—

snow that melts
and freezes at the same time

a viola bow frayed
from a hundred years of use

Tired from the inside out
I need new words for tired

Ellen Goldsmith

———————————————

Taking on the topic of my breast cancer in my poetry allowed me to be with and to look at my illness. Bringing the poems to my poetry group, getting reactions and criticisms about the language, line breaks, titles, strength of image, was healing. Writing the poems claimed my experiences; working on them opened doors and windows to move beyond.

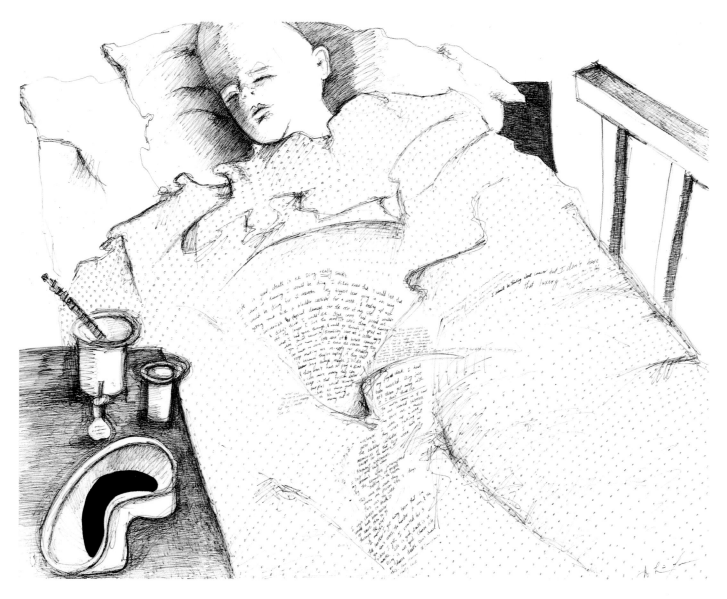

MICHELLE'S FEELINGS
Arlene G. Linder/Michelle Lee Linder
1996
29″ x 23″
PEN AND INK

For the month that my daughter lay in isolation at UC Medical Center, struggling to stay alive after a bone marrow transplant, I sat with my husband either praying or drawing. When she had recovered enough, I asked her to write her feelings into some of the drawings. She did this here. I remember sitting at her bedside peering out the window as night begins to descend. Michelle's breathing is even as she also descends into sleep.

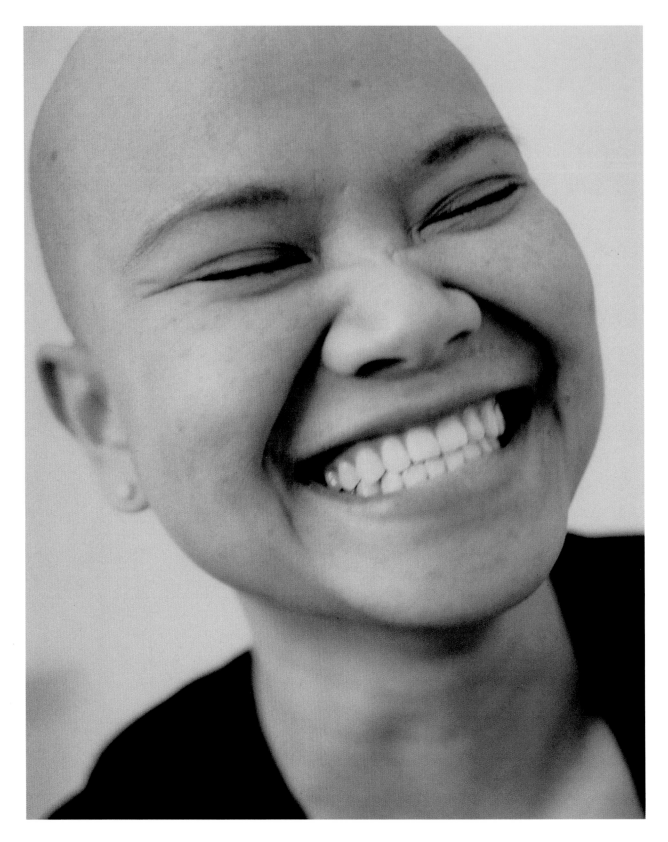

KHARMEN

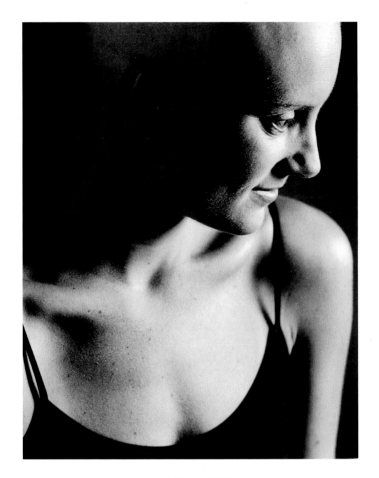

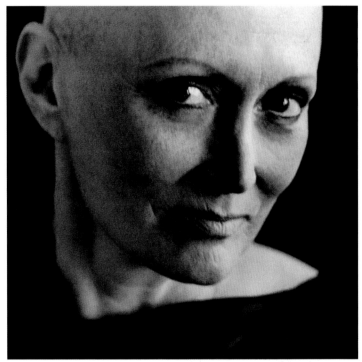

SELF-PORTRAIT DARRYL

KHARMEN, SELF-PORTRAIT, DARRYL
Gwen Rodgers
1997
8″ x 10″
BLACK AND WHITE PHOTOGRAPHIC SERIES

I was diagnosed in 1996 at the age of 25. At first fertility issues were my main worry. Once I found that my options were encouraging, I began to worry about losing my hair. I went from wanting a good wig to realizing that my purpose in wearing it would be to be more acceptable to people I didn't even know. The people I know and care about would still see me as me, bald or not. The anticipation of losing my hair was worse than actually losing it. Once I was comfortable with being bald, I took this self-portrait of myself. Since then, it's grown into a photographic study of other women with breast cancer.

STILL LIFE, LIFE, STILL
Susan B. Markisz
1989
20" x 16"
SILVER GELATIN PRINT

The day I was fitted for my prosthesis was some-
what of a liberation. I could finally throw away
the piece of cotton that was always riding up in
my bra. I felt symmetrical again. One problem.
I would have to wait a week for my new bras to
have pockets sewn in them, but the seamstress
assured me that the prosthesis wouldn't fall out
unless I did heavy aerobic exercises. The next
morning, I went to the local college, where a
small exhibit of my photographs was being
installed. As I bent down to pick up one of the
pictures, out sailed this squishy pink blob,
landing right on top of the glass. Before my eyes
had a chance to mist up from embarrassment, I
quickly picked up the prosthesis, lifted my
sweater, and put it back inside my bra. The
two gentlemen with me were unfazed.

This is so unfair -- it's so unfair that it took two years to find a doctor to take my lump seriously. It's so unfair that I may not be able to see my children grow up. It's so unfair that I may not be able to grow old with my husband! I don't know where I'm going to find the strength to deal with all of this.

Chris is so quiet. I'm really worried about him. When we told him I had cancer he immediately asked me if I was going to die. I tried to reassure him - but not knowing what lies ahead, how can I?

KATHY'S JOURNAL
ENDURING BREAST CANCER
Susan Dooley and Kathy Geiger
1993–97

16″ x 20″

PHOTOGRAPHY AND JOURNAL

"Kathy's Journal" is the result of a collaboration between Kathy Geiger, a breast cancer survivor, and her best friend, Susan Dooley. Most of the writing is excerpted from Kathy's journals, and the photographs were made by Susan. "The journal became a method of coping with the reality of the disease, both for myself and for Kathy," Susan says. "Looking back, we are both thankful we had that release and are hopeful that it is a finished piece."

my thoughts have been so preoccupied with breast cancer. There's not much room for anything else. I find myself drifting, worrying, wondering whether or not the cancer has spread to other parts of my body. I'm numb. and as for Paul ... he's been sleeping a lot lately.

Thank God no lymph node involvement. Still, the loss I'm feeling is so overwhelming — I ache to be whole again.

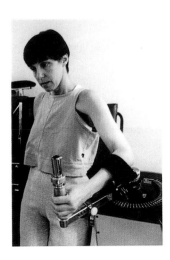

This is so bizarre! I would have given anything when I was thirteen to have my choice of one of these — they jiggle, they're soft, they're waterproof, and you can buy them as big as you want!

"The pectoralis minor muscle is not significant to the human species ... only to species of flight." My surgeon tells me this. I'd like to see him try to roll down the window of his car without it!

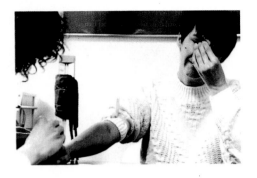

Needles! I've always hated them as far back as I can remember. It figures I'd come down with a disease that required extended treatment involving needles.

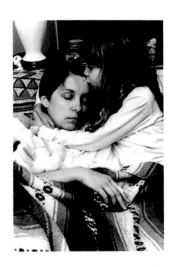

In six months the cumulative effects of chemo have really weakened me. I've reached my limit. I'm thankful that this was my last session. I don't think I could have taken another one.

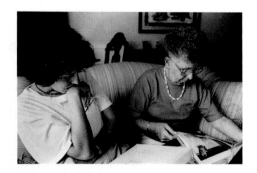

It's so hard looking back, remembering what we've all been through. I still fear a future diagnosis being positive, but most of all I fear for my daughter, Cait... the statistics show she is at high risk. When I think about it, I feel helpless all over again.

No matter what the outcome, the impact of this experience will change our lives forever...

Breast Exam

Betsy Bryant

My breasts are braille in your hands
your long slender fingers
lightly crawling up my frozen chest
sliding over to my questioning, worrying breasts
reading me for bumps, irregularities, odd nodules,
flowing rapidly over to my anxious armpits.
My eyes clamped shut, shunning my own panic,
my future foreshadowed in my breasts.
I am breathing, breathing deeply,
trying to detect alarm in your fingers.
Your faint voice calls me back, "Fine, everything feels fine."
Fine as the quicksand I am still sinking in.

1997

Betsy Bryant

During my year in treatment for breast cancer, I wrote nearly every day. Writing has been a refuge for me as long as I can remember. The process gave silent witness to my pain, bewilderment, and joyous victories. I expressed myself with ruthless honesty and felt more liberated and whole as a result.

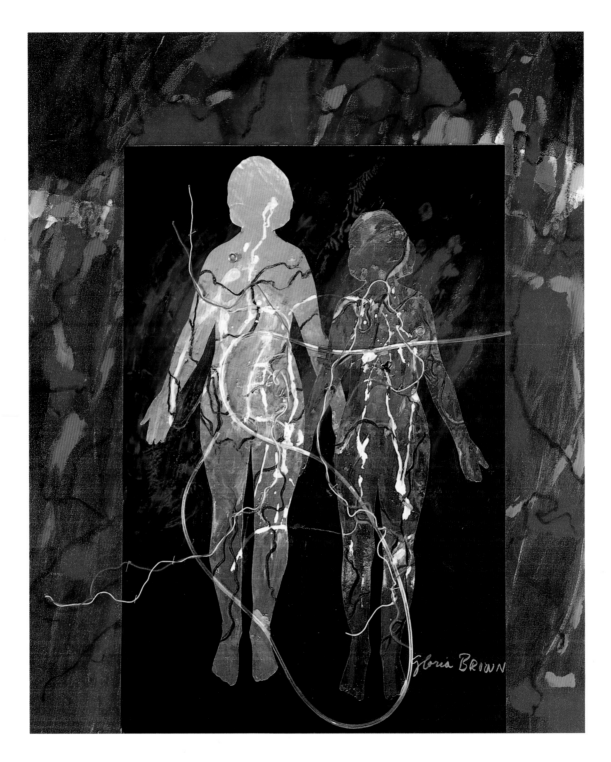

TOGETHER IN THE WILDERNESS
Gloria Brown
1996
30" x 36"
Mixed Media

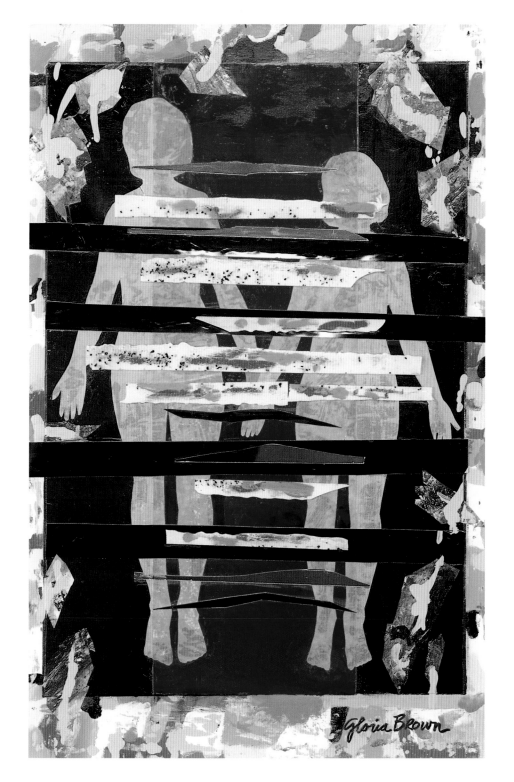

MOTHER AND DAUGHTER
Gloria Brown
1995
24" x 36"
MIXED MEDIA

It was particularly cruel when my daughter came down with cancer. It was bad enough for myself—I was diagnosed five years earlier— but to have Jennifer condemned to it as well was terrifying. It was a wilderness of fear and frustration, of terrible despondency, briefly coming to grips with it and then slipping back again. "Together in the Wilderness," at left, is what it felt like: dark and lonely and terrifying, but together. I also painted "Mother and Daughter"—side by side— bonded by this terrible experience. The black horizontal bars represent the sense of being trapped or blocked from the pleasures of everyday life, which I felt while my daughter was in the hospital for her mastectomy. The glass shards symbolize daggers, danger, and the black around the figures is the unknown. I hoped I could believe myself to be "cured" and healthy. But you can never be certain.

Prosthesis

Susan B. Markisz

The mirror captures
for an instant
your little girl body yearning
for breasts
 —like mine.

I watch
as you hold the soft
contoured form to your chest
and imagine
what it will be like.

I am tempted
to seize the image
etched on my consciousness.
You ask: "May I have it?"

And I say softly: "No, daughter,
never
 —No, never."

Susan B. Markisz

Nine years ago, I came to know the reality of breast cancer. My daughter, Katie, was four at the time. When I wasn't wearing it, she used to play with my prosthesis in front of the mirror. Although I am a photojournalist, the ability to visually document this failed me. But words did not.

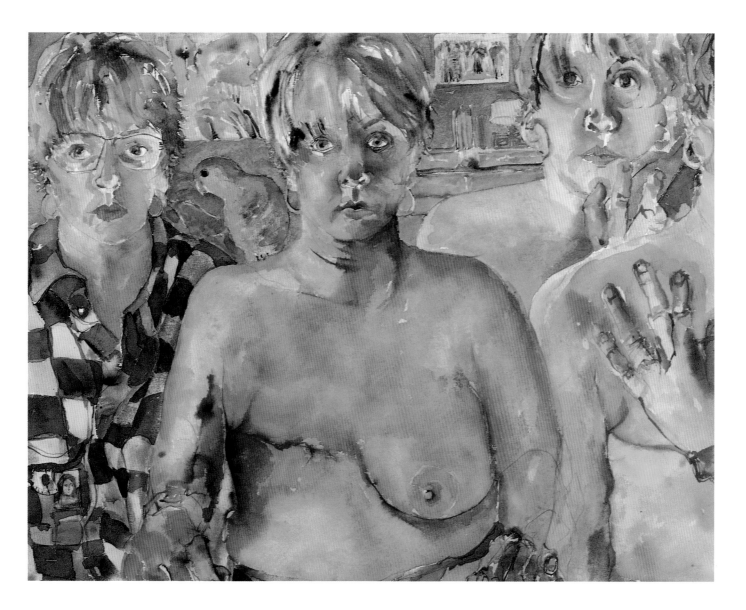

SELF-PORTRAIT

Elissa Hugens Aleshire

1994

22″ x 30″

WATERCOLOR

A week before the surgery, I had drawn a "before" picture, and I had promised myself I would do an "after." It took about three months to work up to it. This painting was the first real look at myself after my surgery, and at first I was embarrassed to even show anyone. But in fact, the process healed me, sitting in front of a mirror looking at an image that scared me. It was late summer, and I was secluded in my bedroom dealing with all this. Then the door banged open, and my three sons and the dog went racing through my bedroom and out to the pool. They didn't even notice me. Since then, I have been at ease with this image.

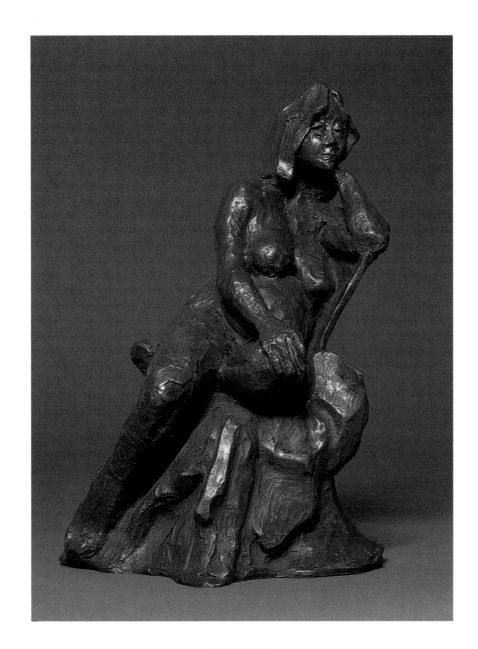

THE WAITING
Lynn Manshel
1994
10" x 12¹/₂"
BRONZE

I started "The Waiting" not long before I was diagnosed with breast cancer, taking on both a new medium, sculpture, and a new theme, pregnant women. As I went through treatment, I realized how much worse it would be if I were still looking forward to having children. I dedicated the piece to all the brave women who, after having had breast cancer, still want to brave the dangers of pregnancy and enjoy the rewards of motherhood.

The Red Dress

Patricia Watt

The Tamoxifen was working. The lung tumors were shrinking, the spinal pain abating, the oncologist celebrating, my family and friends breathing relief. I was somewhat numb. After the initial jubilation I felt lost, disoriented, in limbo again. Uncertainty is perhaps the most difficult state to embrace; it has no substance.

I confessed all this to my friend, Sylvia, over lunch one day and heard that she had sensed my hesitancy, my spiritual reticence. We agreed that something in me which had been preparing to die had not yet been able to rejoin life fully. We also acknowledged that this was not an intellectual dilemma, nor a condition that would yield to the rational.

On my way home in that subdued state, a pre-Christmas sale on books lured me into a mall. Out of a lifetime of habit I could always prepare for Christmas; books could be purchased at half-price and stored away, and my disability-level budget would be glad of it. That same budget allowed nothing for clothes; that much was clear.

Armed with that clarity, I bought my books and then decided to explore the renovations being made to this once familiar place. It was the mall to which Mother and I used to go weekly until her death, for lunch and shopping. Enjoying those memories, I stepped into her favorite dress shop to greet the owner. It was perfectly safe, I knew, because I had never been attracted to their stock for myself.

I was just about to leave, almost home-free, when the cranberry red caught my eye. I probably wouldn't like the style. I did. It probably wouldn't fit. It did. In fact, it was fabulous; and I was fabulous in it.

As soon as I got home I phoned and left Sylvia a message: "Hi, Syl, it's Pat. I just spent over $300 on a red dress. I think I've decided to live."

Patricia Watt

This disease has been a great ravager and a great spiritual guide. "Where does it take me today?" has been a centering question. It has served to focus me on my actual experience and away from infectious statistics, New Age guilt, breast-beating Why Me's. The sharing of my journey in an art form continues to be a metaphor that connects me to women of grace and power all over the world.

THIS COULD KILL ME
Wendy Jordan
1996
$51^1/_2$" x $64^1/_2$"
Textile

It's very strange when you realize that part of your body could kill you. Something so friendly and familiar is now Enemy No. 1. You never know what's going on under your skin, what's changing, what's growing. One day something out of the ordinary shows up on a film or a slide in a lab and bingo—you have cancer. I never expected to feel so betrayed by my body. Having to face myself and the visible evidence of that betrayal every day is a monumental effort. Seeing others recognize that emotion in my art made me see that you don't have to have cancer to feel those feelings. Being human brings that.

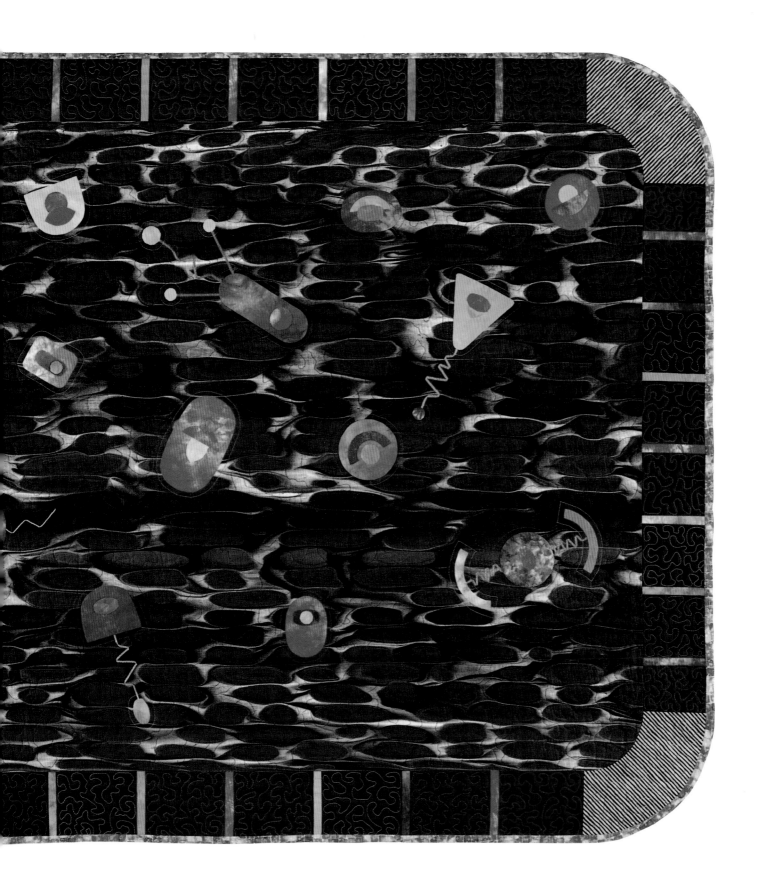

Jean Budington Bateman

This poem is about two sides of me. One is helping a friend to talk about her cancer, the other, slowly opening up to her fears. I recall pacing the length of my home with no one there, no one to talk to about my diagnosis, and because it was Friday night, I could scarcely wait for Monday. The last stanza is pure fiction, although it could have been true. Obviously, I am still alive and in good health.

In Situ

Jean Budington Bateman

Sometimes you know,
without being told.
You simply know.

She has not told me,
yet a sense tells me now
that tests show
she has breast cancer.

She wants to tell me,
doesn't know how to start.
I offer a sentence—
I was lucky with my cancer,
I say,
I didn't lose my hair.
A strange thing to say,
as though hair were important.
But it is something to say,
to help her start.

Still it is
difficult for her to talk.
The image shows, she begins,
salt and pepper splotches
sprinkled throughout my breast.
The biopsy shows cancer.
She speaks quietly,
as though in church.

I'm frightened,
she says.
It's everywhere
in my breast.

The doctor called me
late at night,
after emergency surgery.
Said he had good news—
and bad news.
The bad news is,
you have cancer, he said,
I must remove your breast.

The good news is you have
the most curable form.
Come to my office on Monday,
I'll draw you some pictures.

She rummages in her purse
and pulls out a page
from a prescription pad.
He showed me how
it is growing in the ducts,
and has not yet burst
through the walls.
He called it "in situ."

I walked that night, she said,
walked from the bedroom
to the kitchen,
and back again.
Kitchen to bedroom,
bedroom to kitchen.
My house was too short.
I did not know how
I could wait till Monday.

Three years later
her cancer returns.
Sometimes we are bitter
when we talk of such things.
A thought crosses my mind.
On her tombstone one might write,
"The most curable kind, in situ."

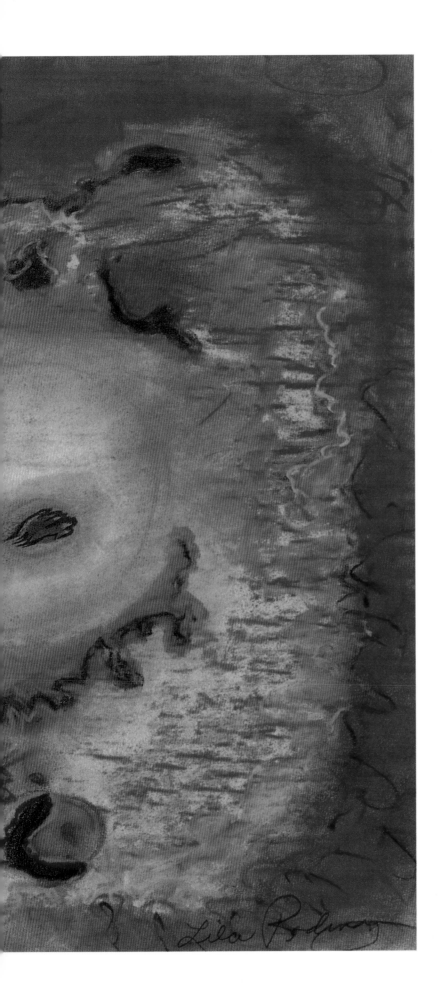

RECURRENCE
Lila Radway
1996
22" x 24"
PASTELS

After my first bout with breast cancer in 1989, which resulted in major surgery and the loss of a breast, I hadn't wanted to paint a thing. A recurrence of the dreadful disease in 1996 prompted me to attend the Ting-Sha Institute in Marin County, California, for emotional and spiritual healing. At the art studio there, the pastels reached out to me. In response to deep self-exploration at the Institute, I found myself creating again, honoring the beauty of my remaining breast and the one I lost.

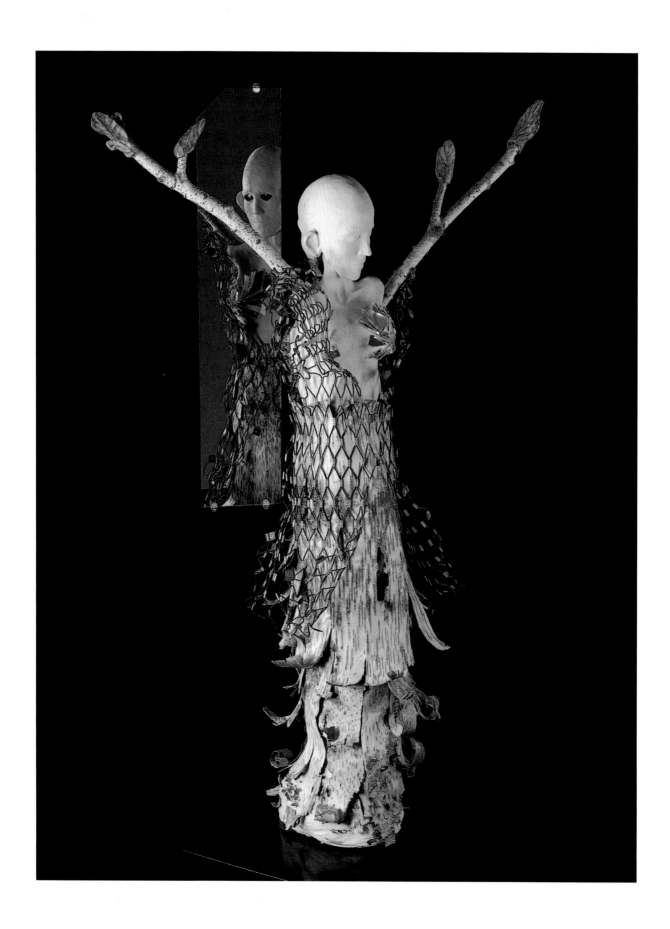

FACING BREAST CANCER—
JOHNNA BECOMES A BIRCH TREE
Pam Golden
1995

71″ x 50″ x 27″

MIXED MEDIA

CLAY, MIRROR, HEMATITE, BIRCH BARK,

BIRCH BRANCHES, WIREMESH

"Facing Breast Cancer—Johnna Becomes a Birch Tree" is a sculpture that reflects my sorrow after my friend Johnna Albi died. When we began working together with her face mask, it was a symbol of hope and prayer for recovery. As the cancer progressed through her body, I felt compelled to create a testimony to Johnna's vitality, strength, and love, while also acknowledging the enormous amount of pain she was enduring. The two-sided mask in the sculpture reflects this duality. The shards of broken mirror covering her breast are a metaphor for all the shattered lives. As I watch Johnna's daughter Ariana become tall and graceful, I like to think of Johnna as a lovely birch tree, a spirit tree, smiling and growing along with us.

BOOK OF FLOWERS VIII
Lynda Fishbourne
1997
15″ x 13½″
ENCAUSTIC/COLLAGE

After I finished chemotherapy and started radiation treatments every day, I also found a new medium, encaustic (wax). It felt like a rebirth in a way. As a reward to myself for my daily hospital visits, I painted in encaustic every day before leaving for my appointment. A series of these paintings resulted. The darker side has petals falling, and the background is etched with counting; it shows what I was leaving behind. The lighter, sunnier side contains written thoughts as well as flowers and leaves from my walks in nature. It reflects the more positive feelings I was having.

BOOK OF FLOWERS IX
Lynda Fishbourne
1997
15″ x 13$\frac{1}{2}$″
ENCAUSTIC/COLLAGE

A NEW DAY BEGINS #2
Anne Bement
1997
11″ x 14″
OILS ON SILVER PRINT

I remember the day as though it were yesterday. After months of meditating and healing following my mastectomy, I felt I was able once again to meet the world . . . not without fears, but with the knowledge that each day would be more valuable than any day that came before I learned I had breast cancer. It is that moment of intense, private recognition that I wanted to express in this photograph: I was rejoining the outer world with optimism and hope.

UNTITLED
Judith K.S. Herman and Wanda Garfield
1993–94
8″ x 10″
PHOTOGRAPHY

Four years ago, my friend Wanda, 34 years of age and a fellow photography student, told me that she had discovered a lump in her breast while showering. That was a Thursday. The following Monday, she had a mammogram and ultrasound exam. Wednesday she got the results. Friday she had a modified radical mastectomy. Wanda asked me to document her healing in photographs, and she kept a journal. Unexpectedly, I found myself working through my own lifelong conviction that I would die of breast cancer.

We began this project to help heal Wanda and also to express our anger that the risk for young women is not taken seriously. Screening is not recommended; it is difficult to get a mammogram; and then it is nearly impossible to have it covered by insurance.

The lead plate in the photograph is a template used in radiation therapy to focus the rays on the cancer, protecting healthy tissue. In fact, although the radiation was aimed at Wanda's chest, she experienced burns on her back. Wanda asked for the plate as a souvenir. We used to joke that if the cancer didn't get her, lead poisoning from keeping the plate in her bedroom might. But she is now mercifully cancer free, reinventing her life and work.

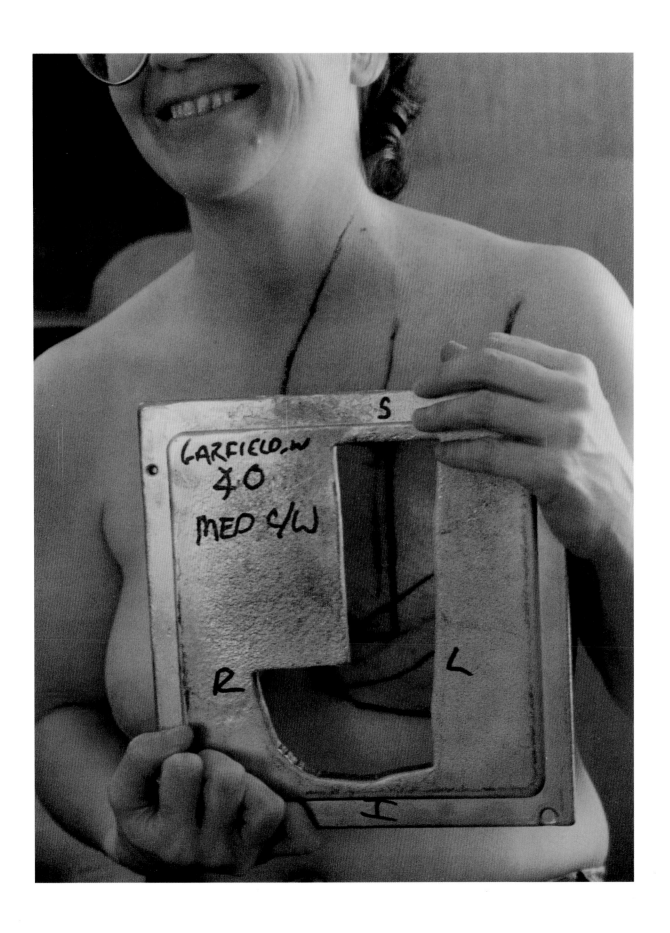

NEATLY WOUND

FRAYING AT THE EDGES

UNRAVELING

REWOUND

Eileen Brabender

1997

5″ x 7″

PHOTOGRAPHIC SERIES

This series of photographs strings together my journey through breast cancer. When I had a suspicious mammogram in June 1992, life changed forever. I stopped being "Neatly Wound" and started "Fraying at the Edges." As breast cancer was confirmed and treatments began, I was "Unraveling." Part of my journey of healing has been to do the things that are important to me now instead of someday. So I began to shoot the black and white photographs I had always planned to take. Life has taken on a new shape with different priorities and I am "Rewound." All of my somedays are today.

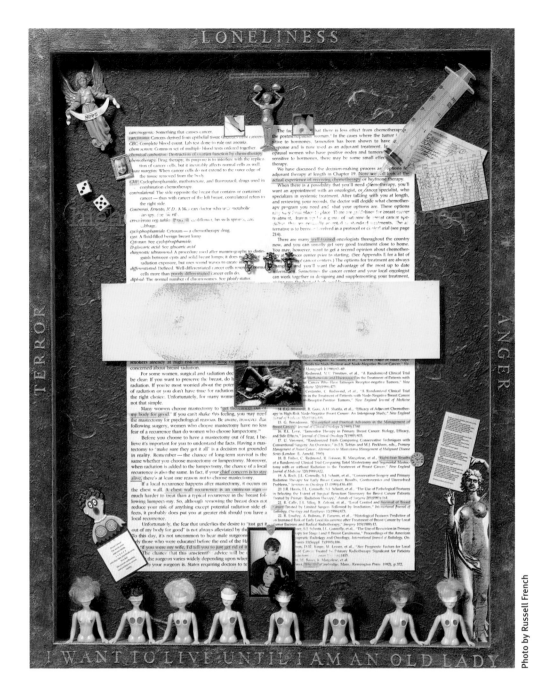

Photo by Russell French

I WANT TO LIVE UNTIL I AM AN OLD LADY

Heather Ann Gilchrist

1997

25" x 32"

Mixed Media Shadow Box

Healing

This shadow box is filled with who I am and what I have experienced through my cancer. These are pieces of my life and my heart frozen in time for everyone to see. There are partial pages of books about cancer, an etching of my breasts I did in college, photographs of me nursing my daughter, the syringe they used to fill my saline implants. Written on the spacer that divides the background and the glass is a fragment of a conversation I had with my daughter:

> *"What are your breasts filled with now, mommy?" said eight-year-old Elisabeth.*
>
> *"Saline, like salt water," I said.*
>
> *"Oh," said Elisabeth, after a moment, "you mean like tears."*
>
> *"Yes, my darling, my breasts are filled with tears."*

—Heather Ann Gilchrist

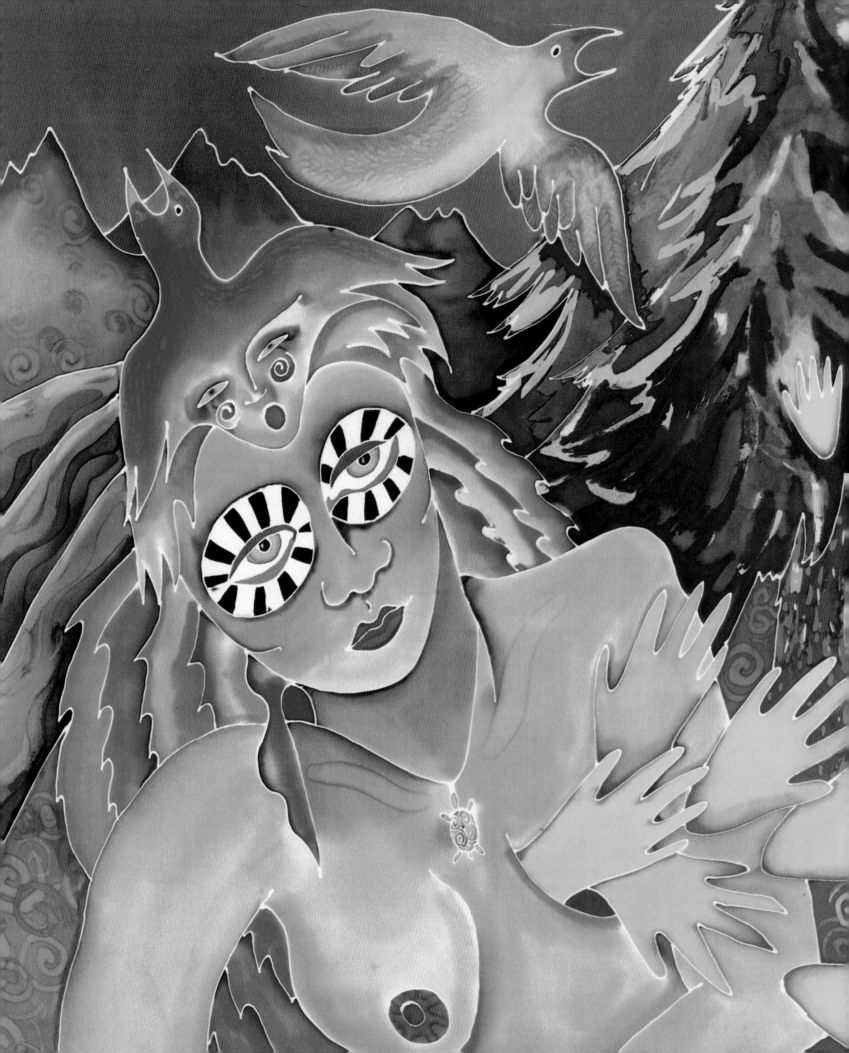

THE HANDS THAT HEAL

Joyce Radtke

1995

28" x 33"

HANDPAINTED SILK

During the year I was diagnosed with breast cancer, I found great comfort in creative visualization. This is one of my favorite images, thousands of shining golden hands coming out of my spirit and into the landscape of my body, picking off the destructive cancer cells.

NIKE OF MASTECTOMY
Kay Minto
1992
29$\frac{1}{2}$" x 29" x 14"
LAVA ROCK AND ALUMINUM

During my brief stay in the hospital, I kept thinking about the Nike of Samothrace, the Greek statue of winged victory. When I got home, I felt compelled to do my own version. I worked for months on the torso, welding and fitting the aluminum. All the while, my left brain's analytical voice kept whispering, "This is a pretty static composition—no dynamic tension. Are you sure this is right?" And yet through experience, I had learned to trust the creative process. I spent another ten days welding a wing. The moment I attached it to the body, the Nike came alive.

Maybe there's a lesson for life here. If I let go of judging what happens to me, then perhaps I can glimpse a larger pattern in life. My challenge now is to live day by day with the same trust I have when my art is unfolding. Ray Bradbury said, "You have to jump off cliffs all the time and build your wings on the way down." For me, completing the Nike was like graduating to a new stage of life, being transformed from an earth-bound being to a woman who can fly.

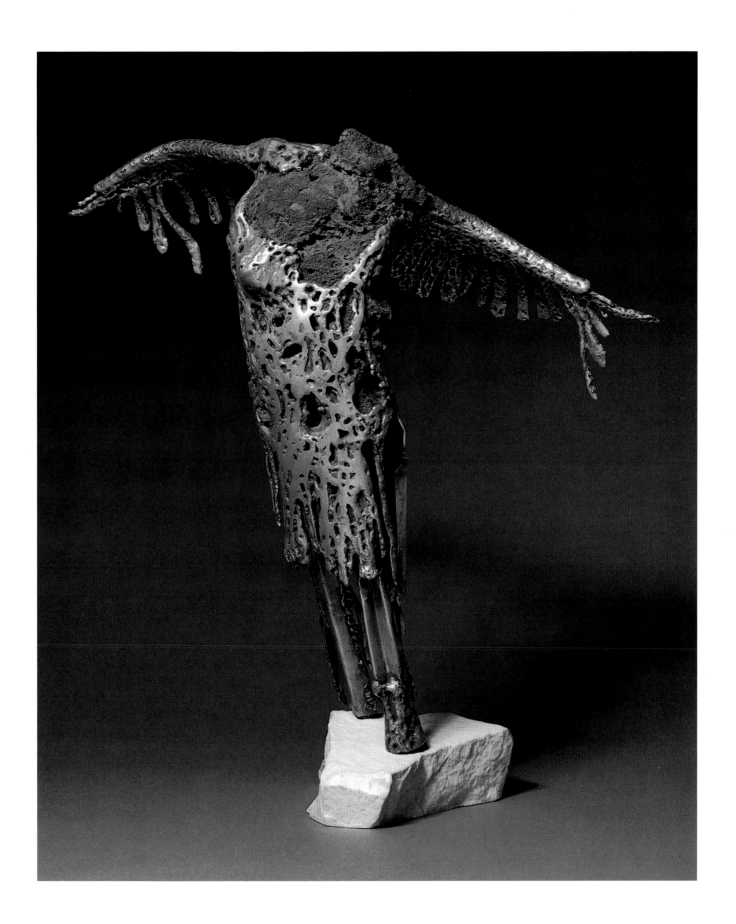

18 June 1992
Favorite Body Parts

Merijane Block

I have a small mirror on a brass stand in my closet. Hidden. The only mirror in the room. It sits on my dresser. So it shows only one part of my body when I stand upright in front of it. If I want to see my face I have to bend over.

It is not my face I want to see when I look in that mirror, nor is it my face I want to write about.

What I see, standing tall before this round mirror bought in Mendocino many years ago, is the exquisite curve that begins with my breasts and ends with my upturned hip. The slope from full breast to slim bony hip, no less "feminine" for its lack of extra padding. This place catches me up short every time I view it, every time I stretch it as I raise my arms to pull a shirt over my head, every time I see it gradually disappear behind the blouse being buttoned, every time I stand half-naked in my closet trying to decide which shirt to cover it with.

I love this part of my body.

During the first dark days of diagnosis I wondered if I would still love it if it lost its symmetry. I decided I would love it still, love it always. It is infinitely exquisite to me, this smooth curve of soft skin, this ever-changing slope of textures and sensations, this meeting of skin and bone, rib and breast tissue, the navel the place that brings it all together. If I could effectively enfold myself from behind, I would do it. I would stand behind myself and hold my breasts in each hand, then slowly slide my hands down my slippery smooth skin, feeling my ribs and the space between them, feeling the perfection of the fit of my hands with my hips, the absolute rightness of placing one's hands on one's hips, not in exasperation or consternation, but in perfect harmony. An ideal resting place, the only place for my hands to rest on my body. In that mirror. In my closet. Just me and me. My body. My life.

Merijane Block

Every Thursday morning after radiation, I met my friend Dennis for writing practice at a cafe close to the hospital. This was one of our timed writing exercises. I've since lost a breast, but I still do love my body—and I still have the mirror.

GUARDIAN ANGEL
Virginia Veach
1996
7" x 3½" x 3" ANGEL
2½" x 4" BOWL
CLAY

The Angel and Bowl are made of clay. They are not glazed but hand rubbed and fired in a pit firing with burnables from the earth. The colors are produced by the various earth materials as they burn. I burnished the pot for many days, connecting the gentle rubbing of the bowl to a mental image of soothing and healing the painful tissue of what was left of my breast. With blessing and prayers, the pieces were placed in the pit. I had no control of how the firing would turn out, but I knew that there would be a profound transformation.

Having breast cancer is this experience for me. We, too, have been through the fire and have no way to predict the outcome, but in some, a remarkable beauty emerges. There is an unspoken sisterhood among women with breast cancer, which is as deep and abiding as is the earth. My healing is part of the healing of us all.

In this piece, the Angel lovingly broods over the Bowl, which has become a symbol of my suffering and my wholeness.

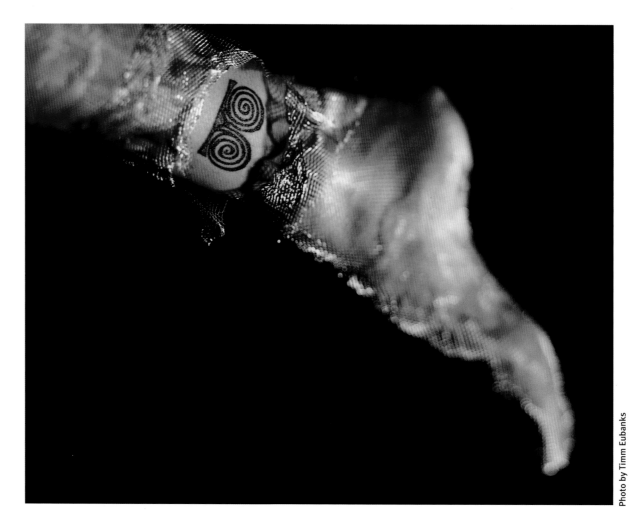

Photo by Timm Eubanks

MY TATTOO
Nancy Bellen
1997
16″ x 20″
PHOTOGRAPH

In preparation for radiation therapy, I acquired five tattoos that provided markers for the treatment. Small as they were, I hated having them. Eventually, my treatment ended; chemotherapy, surgery, radiation. Just as I thought I was through the eye of the storm, I went in for a baseline mammogram and was terrified to discover that a change had appeared on the "unaffected" breast during the months of treatment. Early one morning, lying in bed, not sleeping, I realized this disease could rob me of my time by worry, and I resolved to do some of the things I have been afraid to do. I decided to get a tattoo, some permanent mark of MY choosing to acknowledge strength, power, and survival. It cheered me greatly. I decided upon the ancient symbol that The Breast Cancer Fund and Breast Cancer Action use on their prayer flags to honor women who have faced breast cancer. Discovered in a temple in Malta from a period when matriarchal societies worshipped goddesses, this symbol was worn by female warriors for moral strength during battle. It was a perfect fit. Now I have six tattoos.

I'd like to say that I had kept a diary for years before my diagnosis, because that's what writers are supposed to do. But I didn't, at least not in any regular way. For me, journal writing was something I felt perpetually guilty about: something I wished I did, but never really got around to doing.

Until January 17. I jolted awake in the middle of the night after I was diagnosed with breast cancer, thinking "My God, I might die." My brain started to spin, and I knew I was going to be up for hours. In desperation, I stumbled to my computer and wrote everything that was in my head. I wrote for two hours without stopping. Then I went back to bed and slept.

Jan. 31

Peggy Orenstein

I couldn't stand it any more yesterday and I pulled the tape off the incision from the biopsy. It's longer than I thought— about an inch and a half—and prominent on the top of my breast. It's true if this hadn't turned up anything, I would've been really ticked about the big scar. On the other hand, I wouldn't have cancer.

Over lunch today, an old friend asked me in all seriousness whether I thought I had a "cancer personality." What would that be? Someone who holds anger in, she said. She's been on antidepressants for over a year, and _I_ have the cancer personality?

Maybe deep down the reason it bothers me so much when people say I should change my diet or get rid of stress is that I am afraid I did do something wrong, that this could be a punishment for . . . what? Being on the pill? Waiting to have children? Independence?

It doesn't help that there is a distinct undercurrent of accusation in many of the books supposedly promoting "healing." I can't believe what I've found skimming best sellers in the health sections of bookstores. Bernie Siegel writes, "There are no incurable diseases, only incurable people." Louise Hay claims that cancer returns when a person doesn't make the necessary "mental changes" to cure it. Those are tidy ideas, placing the onus of the illness on the ill and letting the healthy off the hook.

Still, I doubt I gave myself cancer because I'm reluctant to tell one of my best friends she's an idiot.

FACING PAGE:

CIRCUS DE VIDA
Diana DeMille
1995
34" x 43"
COLORED PENCIL ON WOOD

My first mastectomy, in 1991, presaged a half decade of obsessive creation, my way of coping with instead of acknowledging a lopsided scar-slashed chest. I refused to look for five years. Rather, I busied myself with earning two more degrees beyond my M.A., teaching full-time, and creating over eight hours a day. Eventually, my creativity became a means for healing rather than evasion. This is a self-portrait replete with personal symbols of the clown's emotional upheaval and anger with her life. She is the crucified clown trying to walk the tightrope, and she is the clown who tries to balance her life spheres as she makes an obscene gesture. Inner healing cannot begin until the first step is taken: expressing one's anger and rage.

Feb. 15

Peggy Orenstein

Steven and I continue to be testy with one another. I want him to be overjoyed—delirious—that the nodes are clear, but he's just not. He says that he assumed all along I was going to be fine, given what [my surgeon] said. He says if he'd let himself think about anything worse, he would've become so depressed that he couldn't function, he couldn't take care of me.

I want him to react right along with me, but the truth is, I only want him to do it on my terms. As shameful as it is to say, I hate it when Steven's depressed: it scares me. I look to him to be emotionally what he is physically—a solid rock. When he says he's upset that we can't start trying to have a child this spring, I want to shove the sentiment down his throat. I don't like his having feelings that hurt me.

Meanwhile, he's angry that I'm acting as if this is just about me. "If something happens to you, Peg, it happens to both of us," he said. "If you can't have a child, we both can't have a child. If you die"— he began to cry— "if you die, my life ends, too. You have to think about us together, not just you."

Peggy Orenstein

These excerpts are part of a much longer journal I kept to chronicle the new realities of my life. As I tried to come to terms with "the C word," the thing that kept me grounded, kept me able to walk upright, was writing. I wrote because I had to. Because if I didn't, I would explode.

With Right of Survivorship

Lois Tschetter Hjelmstad

(for Ann)

Hard it is to lose a friend
Whose dying could foretell my end

And hard it is to pick up strands
Of living, when those other hands

Are stilled which often soothed my brow
And gave me courage up to now.

There is no way to understand
Why she is gone—and I am here.

September 1991

Lois Tschetter Hjelmstad

Soon after my second mastectomy, my best friend, Ann Keener, lost her battle with breast cancer. One of the hardest things about living and working in this previously unimaginable world is that I am losing, one by one, many of the women with whom I have become very close. But the deep, instant bond I feel with each survivor I meet is an overwhelming gift.

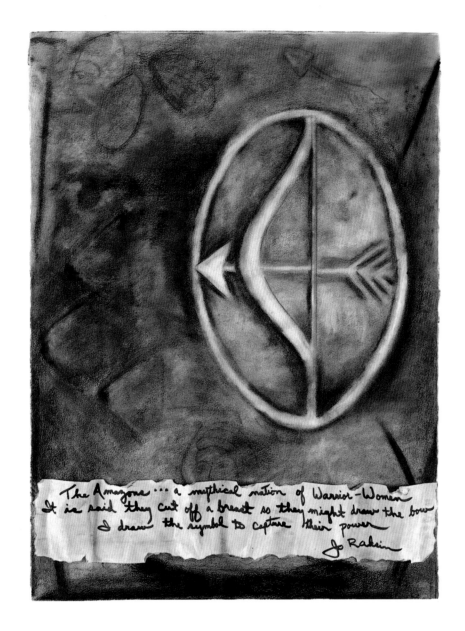

The Amazons ... a mythical nation of Warrior-Women
It is said they cut off a breast so they might draw the bow
I draw the symbol to capture their power
 Jo Raksin

AMAZON HOMAGE
Jo Raksin
1993
34$\frac{1}{2}$" x 26$\frac{1}{2}$"
CHARCOAL AND CONTÉ

According to Greek mythology, the Amazons were female warriors who removed a breast so they could draw a bow more easily. The tale gave me a sense of empowerment when I lost a breast to cancer. Wanting to share this story, I designed a pin and key chain to be made available to others going through the same ordeal. This is an enlarged drawing of the Amazon design.

Affirmation

Lois Tschetter Hjelmstad

The breasts are gone
But I am
Whole

Disfigurement
Need not include
My soul

August 1991

Lois Tschetter Hjelmstad

I would never have chosen this journey, for myself or for you. But it has helped me realize once again, with gratitude and joy, that I have a body—I am a soul.

Photo by Myron Wright

THE GUARDIAN

Marilyn Kaminsky Miller

1996

33" x 69"

Raku-fired Clay, Mounted on Wood and Copper Laminated Frame

After diagnosis and two surgeries, I needed all the help I could find to fight any cancer cells that might be lurking in my body. A totem seemed the perfect answer. Native Alaskans use totems to ward off evil spirits, and so would I. The frog symbolizes the good luck I would need plenty of, the eagle represents strength to see me through treatment, and the wolf a cunning spirit to help me fight the battle with cancer. Man symbolizes the support of family and friends. Now "The Guardian" stands at my door to protect me from cancer and lessen my feelings of terror.

OUR LADY OF PERPETUAL HEALTH
Gwen Thoele
1997
18¹/₂″ x 24″
OIL, GOLD LEAF

During my 20-year experience as a scenic artist, I painted many religious subjects, lots of saints and Virgins ascending. Since my diagnosis and treatment, I've drawn on that experience to create a series of Saints for Our Times. Our Lady of Perpetual Health wears an armored heart and surgical gloves. Around her neck is her token of cancer prevention, a broccoli floret. She contemplates her germ-free banana with appropriate adoration. Good nutrition is an important part of healing, you know!

Jacqueline A. Tasch

Although I have often written as a way of releasing emotions—or even discovering what they are—I did not begin to write about my experiences with breast cancer until the first anniversary of my diagnosis. Persevering through treatment seemed to suck up all the emotional energy I had.

This is one of the stories I was just dying to tell when my self-imposed silence ended. A dozen or more essays poured out over a month's time. During the year of silence, I had worried that I might not remember everything I was feeling. But as I wrote, I wondered how I could have believed, even for a moment, that I would ever forget.

Fools Rush In, Bearing Advice

Jacqueline A. Tasch

In appearance, she was like a reflection of myself in a fun house mirror. A little shorter and quite a bit plumper, her hair and eyes paler. She looked like the fairy godmother in Cinderella, utterly harmless, even sympathetic. And my guard was down. We had just left Sunday services, after all. We were at coffee hour, a place to greet old friends and meet new ones.

"I heard you have breast cancer," she said. "I was diagnosed myself a couple of years ago. I know what you're going through."

I nodded. Breast cancer was not always my favorite subject, but I appreciated her sympathy. "Thanks," I said, "I'm doing pretty well these days."

"There are a lot of us in the congregation, you know," she went on, listing names I had never heard. "I've thought that maybe we should form a support group. Would you be interested?"

I shook my head more vigorously this time. "No," I said. "I tried a group, and it's just not what I need right now. I found it very depressing. Actually, these days, I'm grateful when I can forget what's going on with me for a little while. Like this morning," I said, hoping to underline my point. "It's a pretty day, and I've just been to church. I'm feeling pretty good. I don't want to mess with that."

But if she was listening, she wasn't hearing what I meant.

"Oh, but it's important for you to talk about it," she said. "You know, the cancer won't go away until you deal with the issues that caused it."

My throat tightened.

"All of us," she said, "we get cancer because somewhere deep inside we want to die, and we need to heal that wound before we can get well. Otherwise the cancer will keep coming back again and again."

There was more conversation before I managed to escape, but the damage had been done. It was days before I stopped being angry. How could she be so hurtful, I wondered, when I had gone out of my way to explain why I didn't want to discuss this? Instead of telling her off—a woman I had never met before this one bad episode—I told

others about her, not by name, but by way of example. Now I'm telling you.

This woman was at the lethal end of a scale of "helpers" and "explainers"—people who either know why you got your cancer or how to fix it, or both.

Some friends would say to me, "well, you smoked all those years." I stopped 10 years ago. Women who smoke longer never get breast cancer. Women who never smoke do.

Everyone in San Francisco wants to know why the incidence of breast cancer is higher in the Bay Area than in other parts of the country. Some say it's microwaves from the tower on Twin Peaks. Wow, I thought: I could see that tower from my living room in the first flat I rented here. Others think it's in the water or the soil or the air. One woman I met, a breast cancer veteran like myself, blamed it on the wine. In a health-conscious, sophisticated community, women drink more wine, she said. Wow, I thought: Just before my surgery, I spent a whole day driving through the vineyards of the Napa Valley.

Lots of people offer therapies: Books abound, imploring you to eat your broccoli, meditate, wear a crystal, do acupuncture, take this pill or that potion—all of them offering reassurance. Do this and your cancer will disappear. Do this and you won't die.

My would-be friend from church was just in the worst subgroup of this sorry lot. She thought my inner death wish was killing me. Others point to suppressed anger, or too much expressed anger, or depression, or stress, or a passive personality type. I suppose she got to me because I had bought these explanations to some degree, when the cancer was in someone else's body. Me, I was a Type A personality, destined for heart attack or stroke, never cancer. Or so I thought.

I think the impulse to explain arises from our need to prove that "this can't happen to me." I'm overweight or a smoker or a drinker of wine—you're not, so you're safe. The psychological explanations are a variant: if you can cause cancer with your thoughts/emotions, you can fix it the same way. All you have to do is think happy thoughts and you'll be OK.

I wish.

FANTASY OF FEAR
Wendy Jordan
1997
28″ x 48¹/₂″
TEXTILE

Sometimes I feel like I'm surrounded by people with cancer. Will the people I love ever stop getting sick? This piece came out of a dream I had after learning my brother's father-in-law had cancer. For weeks, working in my studio, I thought this was a piece about worry. But it just wouldn't come together. Then one day, I walked into the studio tired and frustrated and just sat there thinking. That was when it hit me that this was not about worry, this was about fear. Fear of recurrence, fear of chemo, fear of death. From that moment on, I've accepted my fear. It means I'm alive and kicking.

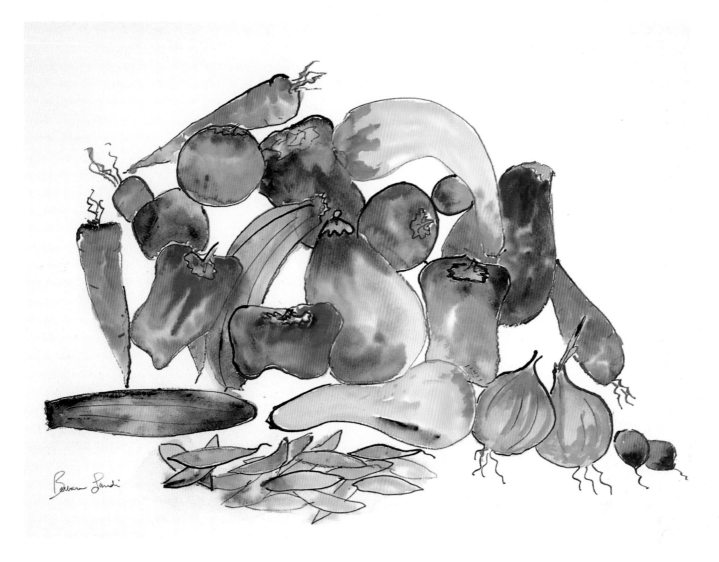

DREAM HARVEST
Barbara J. Landi
1997
18" x 24"
Watercolor

I used to live on a farm in south-central Alaska, where I planted an enormous garden each summer. Besides gorging on fresh vegetables, I froze much of the harvest to last through the long Alaskan winter. I was lean and healthy from working hard, and I was sure my diet—so rich in those terrific vegetables—would keep me fit for many years. When I found out I had breast cancer, I was amazed that such a thing could happen to me.

I moved to Anchorage, and for several years, I had no garden at all. During that time, I started painting watercolors at a healing art group for breast cancer survivors. I decided to paint some of the wonderful vegetables I used to grow. You can "plant" anything on paper, so I also painted vegetables I had only dreamed of growing because Alaskan summers are too cool and too short.

My painting represents the harvest of the garden of my dreams. When I am laying down on paper the vibrant colors of my favorite crops, I taste the sweetness of the fruits in my imagination. I stop thinking about cancer, I go on with my life, and I feel healed at last.

VENUS REVISITED
Carole Bonicelli
1995
45″ x 45″
PAINTING ON SILK

––

Artists use the transformative power of paint and clay to magnify and explain mere singular experience. As an artist who teaches, I wondered how I could make my experience with breast cancer relevant to my teenage students. Using the familiar image of Botticelli's Venus as a metaphor, I painted an altered vision of feminine beauty. When asked to describe the differences between the original painting and my version, the girl students talked about changes in the flowers and the absence of the ocean. The boys said, "She's only got one breast." So the girls avoided the subject, while the boys focused obsessively on it. To me, her eyes, serene but touched by sadness, reflect awareness of her wound, but her beauty is unmarred. We are, after all, more than the sum of our parts.

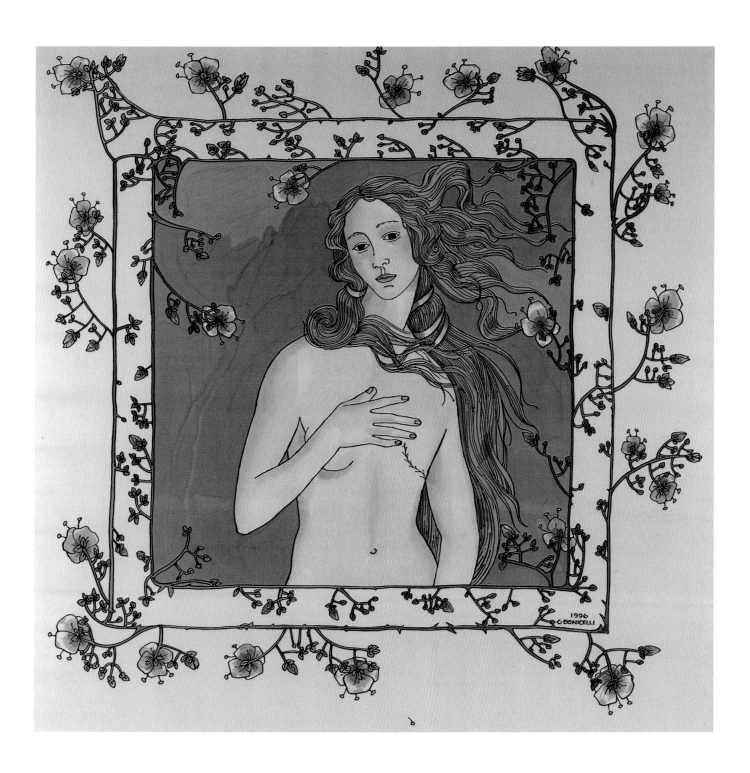

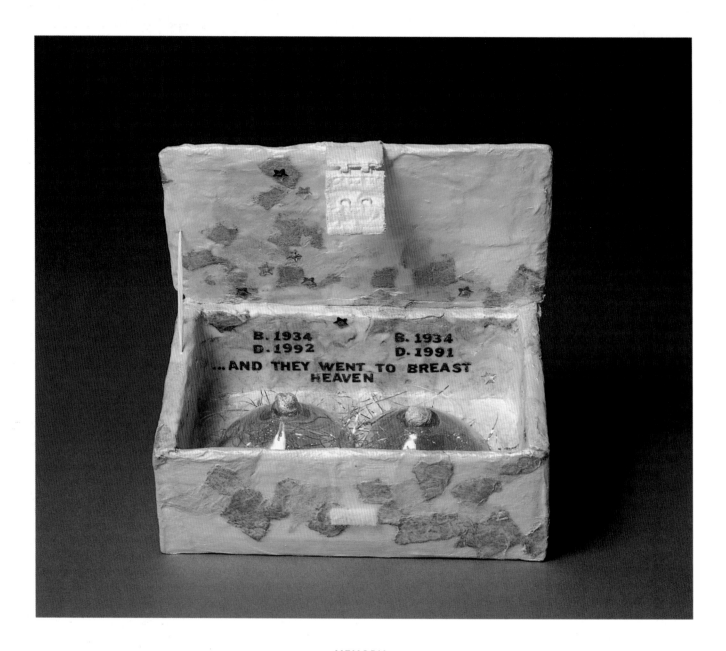

MEMORIA

Barbara L. Peterson

1993

7³/₄″ x 4¹/₄″

MIXED MEDIA

"Memoria" is a personal bit of serious whimsy. It is a farewell, a memorial, a reliquary of sorts. The box is handmade paper, and the "breasts" are the broken bases of handblown glass goblets, rejects retrieved from the dump pile behind a glass-blowing studio. These damaged little castoffs presented an empathetic parallel to my damaged and cast-off breasts. The work helped me turn the corner from grieving to getting on with life. It marked both a conclusion and a new beginning.

SURVIVING WITHOUT THE CAN, SIR

Kelly ForsbergSaid

1997

4" x 5"

CERAMIC

The last 10 years of my life have been centered around cancer. After I was diagnosed, I had a year of treatments. I started volunteering in a Cancer Center and quit work so I'd have more time to help others. I've dealt with three recurrences to the spine, more radiation, and a bone marrow transplant. I've volunteered thousands of hours and worked with hundreds of people who have cancer. A friend challenged me to do something that was not cancer-related. I thought, "That could open a can of worms." My worms are crazy and vibrant—exactly the way I want to spend the rest of my life.

The Gift

Susan B. Markisz

I spent years tracing
the jagged scar across my leftover left bosom,
visual observer, intent
on finding elusive truths.

I spent what seemed a lifetime
tracing the bird's-eye view of a river of tears
across my no longer nurturing left breast,
voyeur with a camera turned inward
in exploration
in anger
in hopelessness . . .
hope

We met over tea.
My words spoke self-deception,
his silence, volumes
tomes of understanding,
far beyond his years of chronology.

He knew me in that moment,
"wound of the heart, not of the flesh,"
he said
while gently tracing
that perfectly jagged, finely etched opening
to my soul.

I race for closure—
he holds me there,
searingly vulnerable.

Susan B. Markisz

*Shortly after I was diagnosed, I embarked on a series of self-portraits
in search of emotional healing. Photography and writing probably helped
to save my life. A young poet looked at one of these portraits, "The
Road Back." His observation about the photo and me, whom he hardly
knew, filled my eyes with tears of unresolved pain—and gratitude
for the validation.*

WINGS OF TRANSCENDENCE
Cecelia Rawlings Thorner
1995
56″ x 56″ x 8″
MIXED MEDIA, FIBER

My experience with cancer left me feeling robbed of the power to affect my life, and yet, the sense of loss was the spark that ignited my journey of self-realization. This sculpture is a physical expression of that journey, an artistic manifestation of the spiritual transcendence I experienced. The healing this process has fostered has given me a sense of joy, of calm, and of wholeness. I have truly crossed over into a place I have never been before.

Sailing

Christina Middlebrook

Christina Middlebrook

I can't forget my doctor's casual statement that metastatic breast cancer was "inevitably fatal." With the bone marrow transplant, I now had a 35% chance of living 3 years without progression of the disease, he said. In other words, I had bought myself a 35% chance of living off chemotherapy for three years, before I entered the final stages of my cancer-ridden life.

"Sailing," which I wrote the summer after enduring that transplant, was written to bridge the gap between my return to life and my preparation for an early death. Doing both simultaneously is a precarious task. In writing, a successful metaphor (like sailing on Lake Tahoe) enlarges the psychic picture beyond the limited medical prognosis. I hope that the reader, like the author, can experience the spectre of death in living terms.

I am at the tiller. The gusty Lake Tahoe winds bat at the mainsail, first from the starboard side, then from port. Jonathan is being patient and I am swearing. We are trying to bring a rented 14-foot Laser II back into the harbor. The wind is capricious and offshore.

Our butts are bruised from landing on strangely placed deck cleats, our fifty-year-old knees sorely tested in the too small cockpit. We have just spent four hours climbing over each other, tangling in multi-colored nylon lines, giving each other instructions, comparing anecdotes from thirty years ago when we each used to go sailing.

A Laser II, we are learning, is designed for one person, a racing person. That we are not racing people is evident each time we come about and the sails flap sloppily while we try to get our bodies arranged. Jonathan names the cleats these sleek sailboats have nowadays, cleats that catch the main and jib sheets and hold them for you, "snatch blocks." We are having a wonderful time.

When he speaks of snatch blocks, Jonathan fixes the jib sheet in one so his right hand is free to pat my thigh. People tell me that I look good these days. I find it disconcerting. On the Tuesday morning before we came up here, I found myself in conversation with the pleasant looking man, perhaps a little younger than I, who shares a waiting room with me before our appointments with our analysts.

He told me (his first words to me after months of waiting together without looking at each other), "You are really looking good."

This comment might have stirred my hormones two years ago. Now I am visited by self-consciousness. I respond "Thank you" with my voice shy as a six-year-old.

"The change," he continues, "is really quite remarkable."

I check out the cover on the latest *New Yorker.* "It's been a rough go," I speak to a William Hamilton cartoon.

"I'll bet it has," he smiles, quite kindly. "Congratulations."

"Thank you," is all I can think to say, again.

This man obviously has understood why I have looked so ravaged over the past year. His words to me are quite sensitive, but I am humiliated. I still cannot imagine how sick I looked while they were trying to cure me. Now that the treatment is over, and we have no idea what my prognosis is, people think that I am well. Most do not follow my metaphor when I speak of the unpredictable Lake Tahoe winds.

"You're a miracle," they say.

"An inspiration to us all."

I hear this every day, just because the grey and shaky effects of my cancer therapy have dissipated. The treatment, which turned me into a Holocaust victim, is confused with the illness, which, at the point I am now, has no visible symptoms. I look well. I have survived a bone marrow transplant.

"How are you?" I am asked, many times a day.

Should I give an answer about my blood counts (still below normal), about how thoroughly my body has changed? My sleeplessness? Hot flashes? About the spasm in my jaw that for weeks has prevented me from closing my mouth? I bruise so easily that my fingers turn blue from simply taking off my rings. My feet hurt, lots, all the time.

Shall I tell them how much time Jonathan and I spend debating whether or not it is advisable for me to submit to all the scans (CT, MRI, Bone) and blood tests that will tell us before we need to know that the devil lurks within? Or should I smile and say how good I feel now, how I can swim thirty laps and have gained fifteen pounds?

I don't know how I am.

On Lake Tahoe we sail from calm to gust and back again. During the calm I fiddle with the tiller and mainsheet, trying to coax some speed from the slightest ruffle. "Just where is this wind coming from?" I mutter. Then, from nowhere, the wind picks up and the Laser tips, menacingly, into a steep heel. I panic. Rather than riding the crest, enjoying the speed I've sought, I grab the mainsheet from the snatch block and release the tiller. The Laser obliges by sashaying directly into the wind and returning to an even keel.

I had thought I'd lost all fear.

Everyone asks me and my family if the bone marrow transplant was "successful." They want to know if the cancer is gone, if "they got it all." Often, they cannot hear the answer when we give it. The answer is that a distant metastasis always reoccurs. Reoccurrence is inevitably fatal. The bone marrow transplant has prolonged my life, prolonged the treatment-free time, not saved me. I and my family live daily with the (more than remote) possibility that I am dying.

"Geez, I'm sorry," I tell Jonathan, embarrassed at my own panic. "It'll take me a while to get used to this."

We had fantasized sailing as in the old days, with water rushing over the leeward rail and ourselves hiking out to windward. I think I have lost my nerve.

"This is the first time I've seen you more frightened of something than I," Jonathan remarks.

He is speaking not only of the chemotherapy, radiation, unanesthetised surgeries and the bone marrow transplant, but of Class V rapids, downhill skiing, scuba diving. I introduced him to each. He damned near died running the Caldera on the Upper Klamath River. He went out at the top of this Class V rapid and "swam" it, as they say. He tells me of a calm moment under water when his wrist was momentarily caught between two rocks. "Oh shit. I'm dead," he thought in the second before he worked his hand free. I remember watching him at the mercy of white water, terrified when, at the bottom where the river stilled, he floated on his back without moving. I thought he had broken his back. He tells me that he was collecting his thoughts.

Voluntary risk-taking has been our idea of fun.

Now, sailing, I am startled by his words. Has he never seen me more frightened than he? Has he forgot the great Loma Prieta Earthquake of 1989 when I sat immobilized at Candlestick Park watching the seats above right field bob and weave, slanting perilously into a heel the way the Laser does now? On that day, Jonathan laughed and went for a beer, guessing the quake at 3.2 on the Richter. I stayed in our seats, heart pounding, hands trembling so violently I had to put them in my pockets to still them.

What about the dive at Playa del Carmen when he and James wiggled like eels into a narrow cave to visit a nurse shark? I waited at their feet, my heart pounding so uncontrollably, my breaths coming so fast that I thought I'd suck all the air out of my tank.

The same happens now, when I think we are going to capsize. I think my heart is like a Tom and Jerry cartoon, pulsing from my chest like a respirator sack. Despite the inner commotion, I seem unable to move. At Candlestick Park I did not think to get out from under the concrete overhang which might have fallen on my head. On Lake Tahoe, I freeze motionless as I watch the water rush closer to the cockpit, the foot of the mainsail dip near the waves.

Preparing for death is as inefficient as preparing for what we in San Francisco have come to call "the next Big One." We mean the Earthquake which will bring the city to its knees. Though we all know how to turn off our gas lines and strap our hot water heaters to the wall, how to shore up our foundations and teach our school children to "duck and cover," the truth is we won't be ready. But we try.

Recently, in my own preparation, I asked a mutual friend of my ex-husband to talk with me about how my children might manage with him as the lone, surviving parent. "Oh, you don't really think that's going to happen do you?" she was quick to reassure me, thus depriving me of information she had about my children's future. "You didn't go through all that bone marrow misery for nothing. You are going to be just fine."

The subject changed, and knowledge of my own foreseeable death slid away . . . from her, not from me.

I don't think it ever slips away from me.

I am terrified of capsizing.

Cancer will kill me. It will sneak up on me, make microscopic but lethal invasions into tiny parts of my body without my even knowing it. And as it happens, I will be looking healthy.

In another conversation, Maggie and I are driving home with an old friend after having watched the performance of a play James wrote about a son going crazy when his mother is dying. James is quite vehement that the play is about him, which it is, and not me. It is also about his old girlfriend, Tiffany.

At the U.C. Davis undergraduate playwright festival, Tiffany, James' father and stepmother, Maggie, I, and my old friend Linda, sat in the same section of the theater, hugging each other and crying a lot, much to the annoyance of the non-familial members of the audience.

When the final bows were over and the lights came on, Linda said "Wow, James. You sure write good fiction."

Tiffany, her face entirely bloated with tears, added "Yeah, not a word of truth in it."

On the way home, Linda asks Maggie, most matter-of-factly, whether Maggie thinks it easier to have warning of her mother's death than to be hit unexpectedly, like our friend, Amy, whose mother froze to death during a school field trip on Mt. Hood. Amy was twelve years old at the time.

Maggie is quick to answer, and I agree with her, that having time, having warning is better.

We like at least the illusion of control.

My wish is to sail the Laser on a close haul directly toward the beach. From the middle of the lake, this seems plausible. As we approach shore, however, the wind disappears. For a moment the mainsail sways out at a right

> Cancer will kill me. It will sneak up on me, make microscopic but lethal invasions into tiny parts of my body without my even knowing it. And as it happens, I will be looking healthy.

angle as though we were running free. Then a ripple in the water indicates that the wind comes now from port.

I had thought I'd tack as close-hauled as possible into the offshore wind. If things were predictable, a deft coming-about would put us on a broad reach parallel to the shore toward our mooring. This wind is not predictable. Just fifty yards from the harbor, after another teasing calm which I've endured with my sails so tight as to put the boom right in the cockpit with us, the devil wind picks up speed and slams us from the stern. The Laser bolts forward. The slack mainsail comes to life with the force of it. I am too panicked to grab the mainsheet out of the snatch block.

> I cannot breathe as I watch the leeward deck submerge. . . . Water begins to pour into the cockpit. I have lost control.

We scramble to the highside. I cannot breathe as I watch the leeward deck submerge. The Laser, bound up in too-tight sails, careens over, slowly. The tip of the boom snags under the water, all in slow motion. Water begins to pour into the cockpit. I have lost control.

But the water feels wonderfully cool. I grab my hat and watch Jonathan's head sink below the surface. Then we are treading water, with the skitterish mainsail now like soggy plastic under water. Behind me the hull rolls over slowly. An instinct, thirty years dormant, disentangles me from the sails and lines. The Laser is dead in the water, the mast pointed to the bottom of Lake Tahoe, daggerboard protruding insignificantly erect from its belly.

With Jonathan's weight on the daggerboard to roll the hull and my memory (I remember to release the mainsail from the vacuum that keeps it just beneath the surface) we bring the Laser back to life. The tall mast lurches upright. Teenagers in a power boat have been circling, offering help which we refuse. They cheer and speed away as the mast heaves out of the water.

We appear to be doing well. No one from the power boat looks back over his shoulder to check our progress. They must think that having the Laser upright is cure enough. But when Jonathan tries to heft himself back into the cockpit, the Laser rolls 180 degrees, again. I don't know how we will manage with no help.

Obviously, to keep the Laser from rolling over again, I must clamber back on board first. Jonathan must remain in the water on the far side and hold the boat level. Am I strong enough? It is impossible to lift me in, as he used to lift me out of the bathtub when I first came home from the hospital.

My first effort to lift myself is a miserable failure. I cannot get the center of my weight over the coaming. Anxious now, adrenaline coursing through my veins, I wait in the water, collecting my energy. "You have to do this, Christina," I admonish myself.

Placing my hands on the deck as though it were the side of a swimming pool, I summon all my strength. With a wave buoying my life jacket, I heave myself up. The life jacket catches the coaming and refuses to move. Panting with exertion, I reach for the daggerboard well and pull. Suddenly everything gives. I, like the great mast and sail rolling upright, whoosh over the deck into the cockpit.

Now that I am back on board, it is easy for Jonathan to join me. We sprawl in the cockpit like two upended beetles in life jackets. The boom sways overhead.

"You all right?" he asks.

I am just grinning. I flex my biceps, beat my chest, stoked by having just pulled my full body weight up out of the lake and back into this boat.

"Can you believe it? Can you believe I've ever been sick?" I ask him.

"I can forget it," he laughs.

That night an inexplicable light rises from behind the mountains on the east side of the Tahoe basin. We are sitting on Don and Valerie's deck finishing dinner as daylight changes to night. A grey thunderstorm has just passed by like a locomotive. Jonathan and I have tested the hospitality of our hosts by insisting that we remain outside on the deck with its fabulous view. I am an invalid again, wrapped in extra blankets to keep warm as the temperature drops. They are sharing a bottle of wine. My esophagus is still too raw for alcohol.

Don thinks that the eerie light must be the unfortunate effect of light pollution, that is, the urban lights of Carson City now so strong as to blot out the starlight. Jonathan states that something is seriously wrong . . . that the now brilliant yellow light reflecting off the bottoms of the thunder clouds is light from an A-bomb test in the Nevada desert. I say that it is the Second Coming.

The light grows more and more brilliant.

"This is it, you guys," Valerie says. "Judgment Day."

Then the full moon, as fat, natural and large as all time, slips over the top of the snow-capped range and ascends into the thick clouds above.

No disaster, just the moon performing its cyclic miracle one more time.

The next day Jonathan and I take out the Laser II for another sail. We rig the sails ourselves and generally congratulate ourselves on our increased skill. But I insist that Jonathan take the tiller when we begin the complicated tacking back to our mooring.

The wind is as tricky as ever. Once more I watch the foot of the mainsail dip under the waves, watch white water surge into the cockpit.

The wind is as tricky as ever. Once more I watch the foot of the mainsail dip under the waves, watch white water surge into the cockpit. In the exact same place, the very spot where we capsized yesterday, the wind switches force and direction. It happens more quickly this time. Jonathan loses control, swears "Oh shit not again," just the way he did when they lost track of my records in radiation oncology for the second time.

We plunge into the water with the Laser wrapped around us. Soon the mainsail is trapped beneath the surface of the water, the hull has rolled belly up, just like the day before. This time I am not afraid. The maneuver to right ourselves is routine. We can get used to this.

Once the boat is right again, we make a perfect mooring.

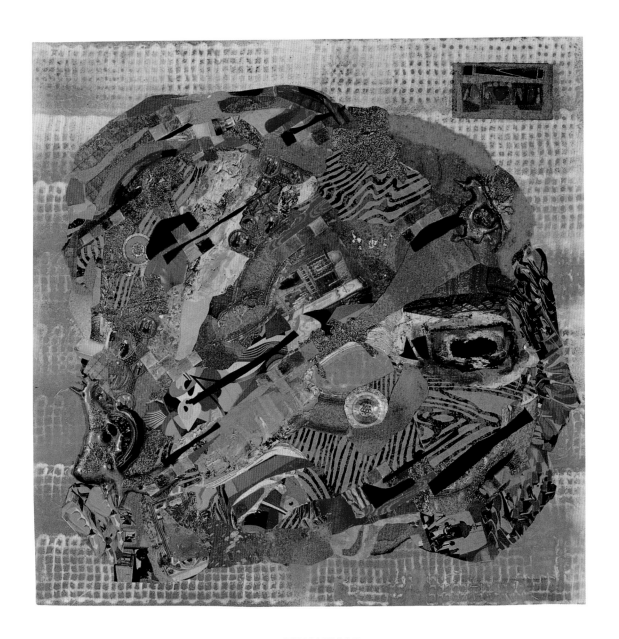

CAMOUFLAGE
Wendy Lilienthal
1996
2' x 2'
COLLAGE

Experimenting with collage, a new direction for my art, was a healing and challenging experience. My creative energy was replenished, and my senses were refreshed. This work represents all the facets of my life coming together at last, as I neared the end of treatment.

CELTIC CROSSES 1.1 – 1.6
Ann Stamm Merrell
1996
ABOUT 15" X 16" EACH
6 QUILTS

When I first started dealing with breast cancer, I became a professional patient. In a way, that was a much easier way to live, because I could clear away all extraneous activities and focus on one thing. Now, as my cancer recedes further into the background, I seem to have once again filled my life with activities. How can I be a saxophonist, a composer, a liturgical Artist-in-Residence, and a quiltmaker—all activities that I'm good at and enjoy—without going crazy? The word simplify presents itself. I still don't know how to simplify my life, but in these quilts I pared down the cross into just two elements, a line (narrow strip of fabric) and a seam perpendicular to the line. Then I tried starting with a circle and adding the line and seam, and the crosses became Celtic crosses. The method of construction is such that the outcome is unknown, even to me, until the last step is completed.

MOTHER AND CHILD
Diana DeMille
1993
48″ x 32″
MIXED MEDIA

When I faced death, my priorities shifted. All my life I'd been like a caterpillar dutifully munching leaves day in and day out. I felt trapped in an upside down cocoon. I ran away from the desert where I'd lived for 50 years to my healing ocean. But when I ran, I left behind an 18-year-old daughter. "Mother and Child" is my portrait of Kathreen and me, my reaching out to her. Every day I passed by this eucalyptus tree and marveled at the length of her great branch, which thrusts 30 feet parallel to the ground. Finally, I understood that her heavy branch does not break because it is supported by her children. Kathreen is, and always has been, my inspiration. Our relationship is healing now, not with her forgiveness but with her understanding of why.

Prayer to My Daughter

Rella Lossy

Now I lay me down to sleep,
I pray the Lord my soul to keep,
And if I die before I wake,
I pray the Lord my soul to take.

And if I die before I wake . . .

Lay my spirit in a lustrous bowl
and make a pilgrimage
to places we have shared:

The Lost Coast Trail—
Go to our first campsite there,
near calla lilies
some defiant housewife
sowed a century ago
(and bless her stubbornness, too).

And the Yosemite High Country—
Where I landed my first bear bag
over a long branch.
We slept by a boulder-studded river,
dived in with raucous shouts,
the sun applauding us.

And then that stonescape
above the tree line,
where my shins bled
as we hiked a razor-rock trail,
the barrenness outside our tent
pocked as the moon.

And if I die before I wake . . .

Take my spirit to those places,
whisper me back into that earth,
that river, those rocks.

Rella Lossy

This is one of several poems Rella Lossy wrote to her daughter and included in the collection, TIME PIECES. Rella edited the galleys and returned them to the publisher just a week before she died, on April 24, 1996. Her husband says, "It seemed that once she had fulfilled this creative ambition, she was prepared for death."

Sabbat

Patricia Watt

We were out for breakfast days after receiving a diagnosis of metastatic disease in spine and lung. "What would you want to do," mused my husband, "if you knew you had only four months?" Four months! I could not deal with that time frame, but I agreed to consider one year. And by the end of my list, it was obvious that I must set my work with others aside.

I love my work as a therapist and retreat leader. Yet it was clearly a necessary sacrifice if I were to go into deep rest and rediscovery of the well within. Over the next four weeks, I wound down, telling clients, grieving with them the loss of our vital soul work together. I cleaned out my files and left the office to others for one full year. I called it a sabbatical because Sabbath means holy time of rest.

Once when my daughter was three I found her sitting in her wee rocker with blanket in hand, two fingers in mouth, looking out over the river. I tiptoed by to work in the kitchen and peeked into the family room every ten minutes or so. Finally, my curiosity won and I asked, "What are you doing, Sweetheart?" Her answer was a lesson. "I not doing anything, Mommy; I just being." Just being is what I want to learn now. How would that sound on the answering machine, I wonder? "Patricia Watt is just being and will not return calls for at least one year."

Patricia Watt

When I was agonizing over the potential side effects of chemotherapy and radiation, my oncologist reminded me gently that cancer has side effects, too. She meant death. But she was more prophetic than she knew and in a wider sense. Cancer has many side effects, and recording them became a significant part of my healing. Healing, not at all the same thing as cure, is a curious reality. I have long believed that healing has everything to do with how we carry our wounds. But my relationship with breast cancer has shown me also how we are carried—by family, friends, symbols, God.

THE ZEN OF BREAST CANCER
BREAST–NO BREAST
Sabina Schulze

1996

40″ x 30″

MONOTYPE

Attending a Japanese brush-painting class a few days after I finished chemotherapy, I sat quietly in meditation. Breathing in and breathing out, big brush in hand, exhaling, I put down a huge black ink circle on white paper. It looked like the full moon of a healthy breast. I completed it with a nipple. This image inspired me to go back to the studio, ink a printing plate, dip the brush in paint thinner, and take out a white breast circle, then make a single line, the line of a scar. The resulting monotype became an obituary. With these simple shapes, I mourn all of our lost body parts.

HEALING

Diana C. Young

1995

14″ x 14″

TONED PHOTOGRAPH

When I was diagnosed with ductal carcinoma in situ in my right breast, I gathered together every bit of information I could find. I studied the odds of survival with various treatments, thought about my mother, who had had breast cancer in both breasts at about my age, and decided to have a bilateral mastectomy. This photograph was made less than a month after my surgery. My husband, Stephen, is at my side, and his love and passion for me shine through for others to see. He has been with me every step of the way, from doctor's appointments to changing of bandages. This experience has made us both stronger, and our relationship is more loving now than I ever thought possible.

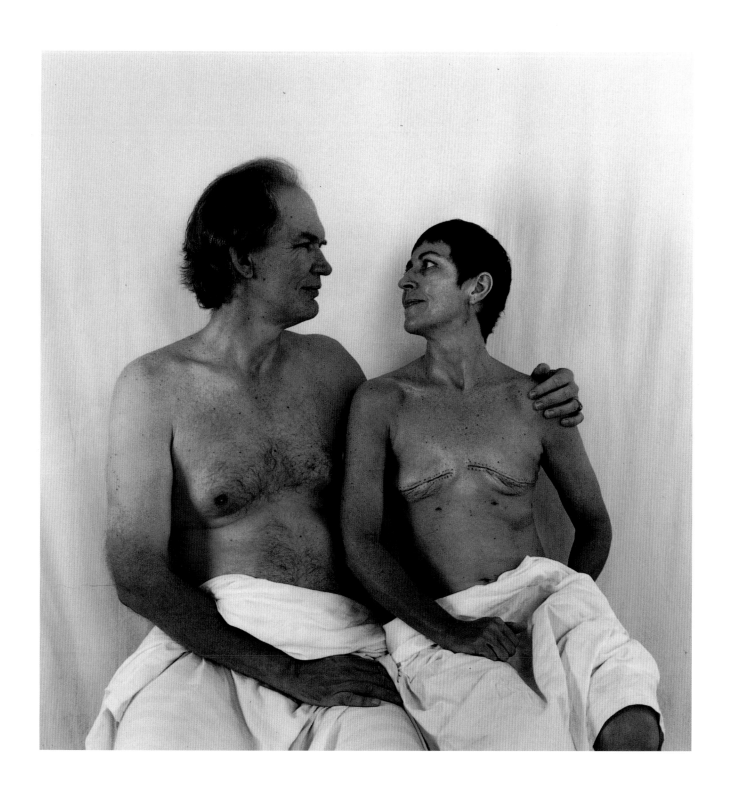

Ghost

Ellen Goldsmith

for Emily

After my first operation, I wanted
a lock on the bathroom door
to keep my daughter from seeing me
She assured me she'd seen her grandmother
undress at night, in the morning
would watch her use straws
to blow air into her empty brassiere

There I am at twenty-five
sitting across the green formica table
from my mother-in-law
a wind blowing from her chest to mine

Ellen Goldsmith

*From the moment I felt a lump in my breast
in March 1990, through two mastectomies,
chemotherapy, and lymphedema, I have been
writing poems. I remember rushing out of a
bone scan, running to the waiting room where
a friend and my daughter were waiting, and
asking for a paper and pencil. "How was
it?" they wanted to know. "Wait, I need to
get this down," was all I would say.*

*Doing this drawing helped me accept my new reflection.
Drawing my scar was only a small part of the work. I
spent much more time drawing my other parts. Through-
out everything, my husband has been the most wonderful,
loving support anyone could wish for. He has helped me
to feel whole and beautiful. I feel great and live in a
heightened awareness of life and death. I continue to strive
for the life I really want to live and work actively to
achieve that life.*

IT'S STILL ME: LIVING WITH BREAST CANCER
Françoise and Denny Hultzapple
1993
19″ x 15″
BLACK AND WHITE PHOTOGRAPH

Denny and I were high school sweethearts, and we had always enjoyed an affectionate, fun-loving, intimate relationship. We had been married 20 years when breast cancer entered our lives. Neither of us ever questioned our love and support of each other through this ordeal, but we wondered whether losing my breast would affect our intimate relationship. After the life-threatening aspects of my breast cancer were resolved, we found that we were every bit as intimate as before. In this photograph, we reaffirm and celebrate this renewal of intimacy, an important facet of our recovery from breast cancer. We also wanted to capture the healing energy being radiated and celebrated.

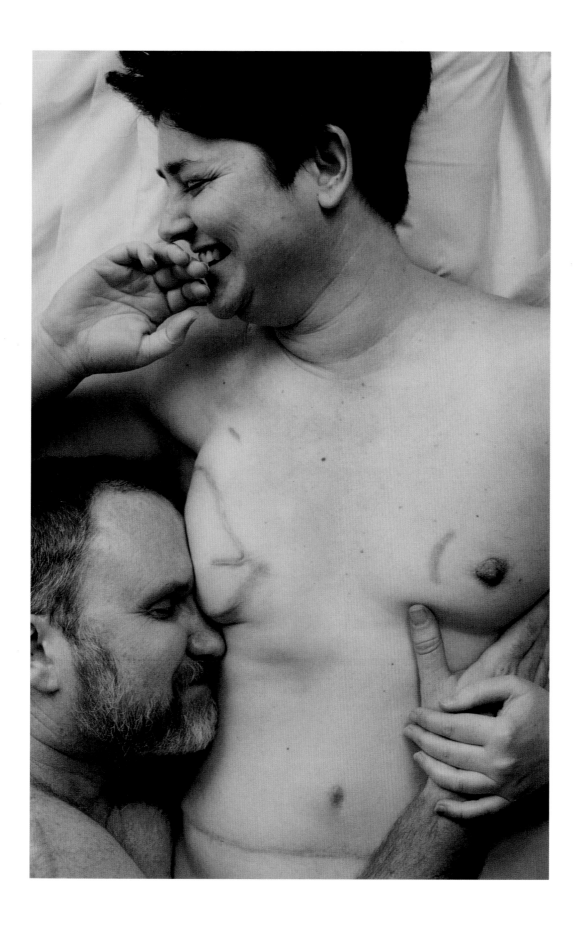

CLEARCUT

The report from the pathologist reads "benign." I do not have breast cancer. This is the fourth biopsy I have had. I am relieved to be healthy but a melancholy hangs over me. My mother had breast cancer, so did my grandmothers. This story tires me, breaks me down, erodes my spine. It is the sick mantra that never goes away. They are dead. I am alive. I wonder why.

Last night, I had a dream. *The mountain across from where we live in Emigration Canyon had been clearcut and domesticated by farms. Green swirls, spirals, patchwork designs became the hillside. I am horrified. My grandmother Lettie is sitting on the chaise in our den. I say to her, "How did this happen and so soon?" She is dressed in white and says nothing. I run outside to see if it is really true.*

My eyes open. The hills beyond our home are still wild. It is only when I look into the mirror that my body reveals the trauma.

In another segment of the dream, *I am creating a narrative on the forest floor out of found objects—pine needles, sticks and branches, pieces of bark, cones, stones, feathers, moss—it is a sentence written in the native voice of the woods. I do not know what it says, only that I am its scribe. What I feel as I place these "letters" on the ground is that it is a way to stay the cutting; long, flowing sentences rising out of the duff that acknowledge the death of trees.*

The poet William Merwin's voice returns to me. "I want to tell what the forests were like. I will have to speak in a forgotten language."

A friend from the forest sends me a large wooden ball. It is made out of yew, yew that heals the cancers of women.

Taxol. This is a tree I know from the Willamette Valley. Pacific yew, so elegant below the towering cedars and firs. I remember watching the slash piles burn, the pungent smell that inevitably follows the chain saws and timber sales. I recall all the clearcuts I have stood in, walked through in Utah, Idaho, Montana, Oregon, Washington, and British Columbia. The silence. The heat. The mutilations. The stumps. The phantom limbs still waving above my head. The hillsides from a distance look like a woman's body prepped for surgery, shaved and cleared, ready for the scalpel.

I hold this yew ball in my hands, close my eyes. What do I see? Heartwood. What do I feel? Wood round like the cyst my body created, now removed by a surgeon I trust, the same surgeon who removed my grandmother's breast, his hands cut and release. What have I released?

Another dream fragment flashes before me—*bear tracks in the snow coming down the mountain. They are filled with blood. I see the blood of my mother and grandmothers. I smell the potent sap of yew, slash and burn, cut and release.* I cup my two breasts, one tender, one firm in my hands.

Where do the clearcut breasts go? Where do the trees go? Where has the tissue of my body been thrown? I was unconscious, anesthetized. I should have asked for it back so I could have buried it in my garden like a sunflower seed. But that is not our option. What is taken from our bodies becomes our pathology—the frozen sections of ourselves placed under a microscope for review. Benign or malignant. We wait for the word.

In the meantime, I daydream, make plans . . . I want to be buried on Antelope Island in Great Salt Lake. It is against the law, but my husband and brothers have promised they will sneak my carapace on to the land, dig a good hole, then cover it with rocks, a fine perch for horned larks. Mormons believe you should be buried with your feet facing east so you can rise in the First Resurrection. "The First Resurrection is yet future and will take place at the time of the Second Coming of Christ. . . . The righteous who live after the Second Coming shall be changed from mortality to immortality in the twinkling of an eye, their bodies and spirits being united inseparably." *(Mormon Doctrine,* pp. 638–639). I want to face west toward the lake, toward the setting sun, toward the unknown, my body easing back into Earth, food for beetles, worms, and microbes. The songs of meadowlarks and curlews will be my voice. Stamping bison over my grave is the only eternal vision I need.

> These moments of acute awareness allow us to claim our deepest desires: I want to live. I want to love. I want more time, here, now, on Earth.

Collisions with mortality always create death dreams, daydreams, creative detours of mind that circle our fears and transform them. These moments of acute awareness allow us to claim our deepest desires: I want to live. I want to love. I want more time, here, now, on Earth. Perhaps this is the gift of illness or biopsies or blood tests or any other momentary pause that allows us to reflect on the delicacy of life, the importance and sustainability of our relations.

The final dream is simple: *My friend from the forest and I are canoeing in a lake. The mountains that surround us are burning, the trees are burning.* When I awaken, my left breast is burning.

Merwin's voice echoes again:

but what came out of the forest
was all part of the story
whatever died on the way
or was named but no longer
recognizable even
what vanished out of the story
finally day after day
was becoming the story
so that when there is no more
story that will be our
story when there is no
forest that will be our forest.

What do I do now with the open space in front of my heart?

ARTISTS/WRITERS

ELISSA HUGENS ALESHIRE
Phoenix, Arizona
Age: 52
Age at diagnosis: 49

JEAN BUDINGTON BATEMAN
Phoenix, Arizona
Age: 74
Age at diagnosis: 69

NANCY BELLEN
Santa Rosa, California
Age: 33
Age at diagnosis: 32

ANNE BEMENT
San Francisco, California

MERIJANE BLOCK
San Francisco, California
Age: 44
Age at diagnoses: 38, 41, 42

CAROLE BONICELLI
Brewster, New York
Age: 57
Age at diagnosis: 50

EILEEN BRABENDER
Los Angeles, California
Age: 62
Age at diagnosis: 57

GLORIA BROWN
Orinda, California
Age: 76
Age at diagnosis: 71

BETSY BRYANT
Mill Valley, California
Age: 46
Age at diagnosis: 44

ROSALIE ANN CASSELL
Berkeley, California
Age: 50
Age at diagnosis: 41

EVA S. COCKCROFT
Venice, California
Age: 58
Age at diagnoses: 56, 57

DIANA DeMILLE
San Luis Obispo, California
Age: 55
Age at diagnoses: 49, 54

SUSAN DOOLEY
Miller Place, New York
Age: 51
Age at diagnosis: 41

KATHY GEIGER
Age: 49
Age at diagnosis: 41

MARY ELLEN EDWARDS-McTAMANEY
Los Gatos, California
Age: 60
Age at diagnosis: 53

LYNDA FISHBOURNE
Framingham, Massachusetts
Age: 49
Age at diagnosis: 48

KELLY FORSBERGSAID
Lathrop, California
Age: 38
Age at diagnoses: 27, 31, 36, 37

NAVA FRANK
Oakland, California
Age: 33
Age at diagnosis: 31

ANITA BOWEN
Age: 31

SYLVIA COLETTE GEHRES
Walnut Creek, California
Age: 65
Age at diagnosis: 62

HEATHER ANN GILCHRIST
Cape Elizabeth, Maine
Age: 41
Age at diagnosis: 38

PAM GOLDEN
Age: 43

JOHNNA ALBI
Age at diagnosis: 47
Age at death: 49

ELLEN GOLDSMITH
Hastings-on-Hudson, New York
Age: 54
Age at diagnosis: 47

LINDA S. GRIGGS
Grand Rapids, Michigan
Age: 47
Age at diagnosis: 43

WENDE HEATH
Point Richmond, California
Age: 56
Age at diagnosis: 54

JUDITH K.S. HERMAN
Nashua, New Hampshire
Age: 58

WANDA GARFIELD
High Springs, Florida
Age: 38
Age at diagnosis: 34

LOIS TSCHETTER HJELMSTAD
Englewood, Colorado
Age: 67
Age at diagnoses: 59, 60

CAROL SUE HOLBROOK
Anchorage, Alaska
Age: 47
Age at diagnoses: 41, 45

IMOGENE FRANKLIN HUBBARD
San Francisco, California
Age: 68
Age at diagnoses: 65, 66

FRANÇOISE G. HULTZAPPLE
York Haven, Pennsylvania
Age: 45
Age at diagnosis: 38
DENNY HULTZAPPLE
Age: 47

ELIZABETH HURST
San Francisco, California
Age: 47
Age at diagnosis: 45

JEANNE HYLAND
Westminster, Colorado
Age: 43
Age at diagnosis: 43

WENDY JORDAN
Indianapolis, Indiana
Age: 34
Age at diagnosis: 31

SUSAN E. KING
Los Angeles, California
Age: 50
Age at diagnosis: 42

BARBARA J. LANDI
Anchorage, Alaska
Age: 49
Age at diagnosis: 46

JENNY LEWIS
Oxford, England
Age: 54
Age at diagnosis: 42

WENDY LILIENTHAL
San Anselmo, California
Age: 77
Age at diagnosis: 73

ARLENE G. LINDER
Novato, California
Age: 60
MICHELLE LEE LINDER
Age: 36
Age at diagnosis: 33

MARLENE GHARBO LINDERMAN
Phoenix, Arizona
Age: 65
Age at diagnosis: 62

RELLA LOSSY
Kensington, California
Age at diagnosis: 60
Age at death: 61

LYNN MANSHEL
Short Hills, New Jersey
Age: 58
Age at diagnoses: 51, 53

SUSAN B. MARKISZ
Bronx, New York
Age: 45
Age at diagnosis: 36

SUZANNE MARSHALL
Clayton, Missouri
Age: 58
Age at diagnosis: 50

MATUSCHKA
New York, New York
Age: 44
Age at diagnosis: 37

ANN STAMM MERRELL
Cupertino, California
Age: 46
Age at diagnosis: 42

SUSAN HERPORT METHVIN
Anniston, Alabama
Age: 51
Age at diagnoses: 38, 50

CHRISTINA MIDDLEBROOK
San Francisco, California
Age: 56
Age at diagnoses: 49, 50

MARILYN KAMINSKY MILLER
Anchorage, Alaska
Age: 53
Age at diagnosis: 52

MARY P. MILTON
El Cerrito, California
Age: 59
Age at diagnosis: 58

KAY MINTO
Eagleville, California
Age: 56
Age at diagnosis: 50

NANCY MCCRACKEN MORGAN
Oak Ridge, Tennessee
Age: 67
Age at diagnosis: 65

KIT MORRIS
San Francisco, California
Age: 42
Age at diagnosis: 41

VIOLET MURAKAMI
Kailua, Hawaii
Age: 45
Age at diagnosis: 43

MARGARET STANTON MURRAY
Corralitos, California
Age: 61
Age at diagnosis: 54

RIA ORANS
Paradise, California
Age: 62
Age at diagnosis: 43

PEGGY ORENSTEIN
Berkeley, California
Age: 36
Age at diagnosis: 35

BARBARA L. PETERSON
Bristol, Indiana
Age: 63
Age at diagnosis: 57

JOYCE RADTKE
Arcata, California
Age: 44
Age at diagnosis: 41

LILA RADWAY
Okemos, Michigan
Age: 58
Age at diagnoses: 50, 57

JO RAKSIN
Valley Village, California
Age: 65
Age at diagnosis: 60

CONSTANCE RICHARDSON
Norwood, Massachusetts
Age: 61
Age at diagnosis: 61

PAMELA ROBERTS
Colrain, Massachusetts
Age: 48
Age at diagnosis: 44

GWEN RODGERS
San Francisco, California
Age: 27
Age at diagnosis: 25

SABINA SCHULZE
Santa Fe, New Mexico
Age: 44
Age at diagnosis: 37

LUCY SHERAK
Woodacre, California
Age at diagnoses: 43, 45
Age at death: 45

MARCIA SMITH
Rochester, New York
Age: 53
Age at diagnosis: 48

ANA SMULIAN
Richmond, California
Age: 45
Age at diagnosis: 44

SHEILA SRIDHARAN
Phoenix, Arizona
Age: 49
Age at diagnosis: 47

VIRGINIA STEARNS
San Francisco, California
Age: 51
Age at diagnosis: 50

JACQUELINE A. TASCH
San Francisco, California
Age: 52
Age at diagnosis: 51

GWEN THOELE
San Francisco, California
Age: 59
Age at diagnosis: 54

CECELIA RAWLINGS THORNER
San Anselmo, California
Age: 58
Age at diagnosis: 38

TRANSFORMS
San Francisco, California
 ELYSE ENG
 Age: 49
 Age at diagnosis: 47
 BRENDA RAE ENO
 Age: 37
 Age at diagnosis: 33
 JODY MAHONEY
 Age: 44
 Age at diagnosis: 43
 KIT MORRIS
 Age: 42
 Age at diagnosis: 41

VIRGINIA VEACH
Point Reyes Station, California
Age: 65
Age at diagnosis: 63

PATRICIA WATT
London, Ontario Canada
Age: 57
Age at diagnoses: 51, 55

WANNA WRIGHT
Emeryville, California
Age: 53
Age at diagnosis: 34

DIANA C. YOUNG
Hattiesburg, Mississippi
Age: 49
Age at diagnosis: 47

Appreciations

Art.Rage.Us. ART JURY

JANET BISHOP
GLORIA BROWN
RICHARD GELERNTER (CHAIR)
KATYA MIN
CINDY PERLIS

> *Assistants:*
> TISHA KENNY
> AGNES DRIVER

Art.Rage.Us. WRITING JURY

MERIJANE BLOCK
NANCY BRUNING
DEBORAH CLAYMON (CHAIR)
NANCY EVANS
ART PETERSON
WANNA WRIGHT

Art.Rage.Us. EXHIBIT DESIGN

NORMAN ANDERSEN
CHRISTIE DAVIS

Art.Rage.Us. COMMUNITY OUTREACH/PROGRAM

TISHA KENNY

Art.Rage.Us. EXHIBIT GUIDES

SHIRLEY DEAN
BEVERLY RIEHM

Art.Rage.Us. PLANNING TEAM

NORMAN ANDERSEN
Norman Andersen Exhibit Design

MERIJANE BLOCK
Women's Cancer Resource Center

GLORIA BROWN
Artist

LINDA CAIN
The Susan G. Komen Breast Cancer Foundation,
 San Francisco Chapter

DIANE CARR
San Francisco Department of Public Health

SUSAN CLAYMON
Breast Cancer Action

CHRISTIE DAVIS
The Oakland Museum of California

LINDA DAVIS
The Susan G. Komen Breast Cancer Foundation,
 San Francisco Chapter

SHIRLEY DEAN
Junior League of San Francisco

KRISTIE DOLD
UCSF-Mt. Zion Cancer Center

CAROL DURHAM
Artist

RICHARD GELERNTER
Artist

GAYLE HAGEN
American Cancer Society

SEAN HANLON
Sperling Sampson West

Appreciations

DR. JAY HARNESS
Highland Hospital

BEVERLY HAYON
Kaiser Permanente

WENDE HEATH
Artist

TISHA KENNY
Health Through Art: Signs of Recovery Project

HANNAH CLAIRE KLEIN
Consultant/Producer

NANCY KULCHYCKI
American Cancer Society

MARY LANIER
California Pacific Medical Center

CAROL LIND
Non-Profit Management

ANDREA MARTIN
The Breast Cancer Fund

ELSPETH MARTIN
Catalog Consultant

LESLIE PAINE
Summit Medical Center

BEVERLY RIEHM
Junior League of San Francisco

GWEN RODGERS
Gwen Rodgers Photography

KATHY SEVERSON
American Cancer Society

DEVEREAUX SMITH
The Susan G. Komen Breast Cancer Foundation,
San Francisco Chapter

MOLI STEINERT
The Breast Cancer Fund

CECELIA RAWLINGS THORNER
Artist

ADA RENEE WILLIAMS
City of San Francisco,
Commission on Status of Women

WANNA WRIGHT
Women's Cancer Resource Center

JEANETTE ZOLOTOFF
M. Cruz Latina Breast Cancer Foundation

Art.Rage.Us. VIDEO ARTISTS

———————————————

NANCY BELLEN
FAYE KAHN
SHERRY THOMAS-ZON

*The sponsors thank the Glenbow Museum staff,
and especially Laura Mann, for advice and expertise.*

*Thanks to Lou Pappalardo and Northern Lights for
film scanning services.*

For information about breast cancer, call:

THE BREAST CANCER FUND 800-487-0492

THE AMERICAN CANCER SOCIETY 800-227-2345

THE SUSAN G. KOMEN BREAST CANCER FOUNDATION 800-462-9273